Art, Science and Art Therapy

of related interest

Art-Based Research
Shaun McNiff
ISBN 1 85302 621 2
ISBN 1 85302 620 4

Handbook of Inquiry in the Arts Therapies
One River, Many Currents
Edited by Helen Payne
Foreword by John Rowan
ISBN 1 85302 153 9

Medical Art Therapy with Adults
Edited by Cathy Malchiodi
Foreword by Richard Lippin
ISBN 1 85302 279 4
ISBN 1 85302 678 6

Medical Art Therapy with Children
Edited by Cathy Malchiodi
Foreword by Judith Rubin
ISBN 1 85302 677 8
ISBN 1 85302 676 X

Art, Science and Art Therapy
Repainting the Picture

Frances F. Kaplan

Jessica Kingsley Publishers
London and Philadelphia

The right of Frances F. Kaplan to be identified as author of this work has been asserted by her in accordance with the Copyright, Designs and Patents Act 1988.

First published in the United Kingdom in 2000 by
Jessica Kingsley Publishers Ltd
116 Pentonville Road
London N1 9JB, England
and
325 Chestnut Street
Philadelphia, PA 19106, USA.
www.jkp.com

Copyright © 2000 Frances F. Kaplan

Library of Congress Cataloging in Publication Data
Kaplan, Frances.
 Art, science and art therapy : repainting the picture / Frances Kaplan.
 p. cm.
 Includes bibliographical references and index.
 ISBN 1-85302-698-0 (pb. : alk. paper) -- ISBN 1-85302-697-2 (hb. : alk. paper)
 1. Art therapy--Philosophy. 2. Art and science. I. Title.
 RC489.A7 K36 2000
 615.8'5156--dc21 99-039966

British Library Cataloguing in Publication Data
Kaplan, Frances
 Art, science and art therapy
 1. Art therapy
 I. Title
 616.8'916'56
 ISBN 1853026972 (hb)
 ISBN 1853026980 (pb)

ISBN 1 85302 697 2 (hb)
ISBN 1 85302 698 0 (pb)

Printed and Bound in Great Britain by
Athenaeum Press, Gateshead, Tyne and Wear

Contents

List of figures

Acknowledgements

A number of people have been very helpful in the writing of this book. First, my thanks go to my publisher and her staff for all their encouragement and assistance in getting the manuscript in order. I can't think of a pleasanter group of people in the book world (or any other) with whom to conduct business. Indeed, this book would not have existed if Jessica Kingsley hadn't suggested that I enlarge upon the paper that preceded the present publication.

Second, thanks are due to Cathy Malchiodi, editor of *Art Therapy: Journal of the American Art Therapy Association*, who gave welcome advice and support and who oversaw the publication of the original paper (1998) that grew into this book ('Scientific art therapy: An integrative and research-based approach.' *Art Therapy: Journal of the American Art Therapy Association 15*, 2, 93–98). In addition to elaborating upon the basic content, some phrases, sentences and a paragraph or two from that paper are scattered throughout this book.

Among the others who deserve especial thanks are several participants in art therapy who kindly gave permission to reproduce their artwork; my son, Jason Kaplan, who did the frontispiece and endpiece illustrations; his good friend (and mine), Summer Tolson, who created the diagrams of the brain; and my husband, Martin Kaplan, who unfailingly lets me know that *I can*.

Frances F. Kaplan
West Linn, Oregon, 1999

Introduction

Repainting the Art Therapy Picture

Most books arise from a personal context. This book is no exception. The particular context from which it arose goes back many years to my undergraduate days during the 1950s. Art therapy had been initiated a decade earlier by Margaret Naumburg in the USA and Adrian Hill in Britain, but was not yet a recognized profession. This was unfortunate for me because I was having trouble choosing a focus for my studies. Torn between art and science, I alternated between classes in studio art and classes in chemistry. I finally decided that what I wanted was to major in something which combined both art and science, but I had no idea what that might be. I turned to several of my professors for help.

One professor suggested that I become a medical illustrator, another that I learn how to restore old paintings (some might call this 'art therapy' of a sort). However, none of these suggestions hit the mark; each had to do with applying the techniques of one discipline to the products of the other. What I wanted was something that somehow combined the processes of both art and science. Eventually, I gave up and graduated with a major in chemistry. Always the practical one, I figured that even not-so-good chemists could count on eating regularly whereas there were no such guarantees for artists.

After a few unhappy years working in a chemistry lab, I decided I had been pursuing the wrong science and started studying psychology at night. I also took more art classes. I thought that maybe I could put the two together somehow. At last the miracle happened. I read an article in the newspaper about an artist who was using art to help emotionally disturbed youth. She spoke about her plans to get a degree in social science in order to be more effective in her work. I do not recall if she gave a name to what she was doing, but I was certain that whatever it was, this

was the combination of art and science I had been seeking. Married now and with an infant son, I resolved to follow in this artist's footsteps when my son was a little older. By the time I was ready, it was the mid-1970s. Art therapy in the USA had become a profession with a name, a number of well-established degree programs and at least some prospects of employment. I could not have been happier.

The honeymoon lasted for quite a few years. It lasted through my graduate training and through my years as a practicing clinician. After I became an art therapy educator, however, I began to realize that not everyone in art therapy saw it as a combination of art and science. Further, among those who did see it this way, I realized most were not really practicing science (i.e. conducting sound research or evaluating what they were doing in the light of existing studies). Ultimately, I became aware – one sees the obstruction in one's own eye last – that even I was not being true to my dream of an integrated discipline.

What slowly dawned on me was that I, along with most of my colleagues, had been perpetuating a tradition of science neglect. The first generation of art therapists, whose influence is still strong given the youth of the profession, set an example that has continued to be followed. Although logical as well as creative thinkers, these pioneers accepted at face value the ideas of the eminent therapists whose psychodynamic theories they appropriated. Perhaps, as people schooled in the humanities rather than the sciences, they considered psychoanalysis and its offshoots all the science they needed. In any case, they were more at home with hermeneutics than research and produced few solid studies. Art therapy education today very much bears their imprint. In my experience as student and teacher, art therapy students may be told that research is a good thing and even given a little instruction in research methodology, but they are generally not encouraged to question the wisdom of the elders of either psychotherapy or art therapy. Further, this tradition of neglect, of valuing authority over scientific inquiry, has been aided and abetted by certain influences from the culture at large. (I will have more to say about this in the following chapter.)

The turning point for me – as often happens with educators – was a remark made by a student. To be precise, the young woman was a prospective student whom I was interviewing. I had asked the interviewee why she wanted to attend my university's art therapy program. She told

me about a workshop she had attended given by an art therapist who offered private training. She expressed displeasure at being asked to disclose her astrology sign at the beginning of the workshop and declared, 'Your program is more scientific.'

At first I was flattered by this remark. I felt smug that it was recognized that I taught 'scientific art therapy'. But the smugness soon dissipated as I realized that the time had come to work out what a scientific approach to art therapy truly meant. This led to a more comprehensive delving into the literature of a variety of research disciplines than I had previously attempted. The more I read, the more I became convinced that our current picture of art therapy needs repainting. There are presently many fuzzy areas that need clarifying and many assumptions that once seemed valid, but do not stand up when scrutinized in the light of recent scientific research. Some of what needs to be done awaits art therapy research. Much of it can be accomplished, or at least begun, by taking into account what is now known about the brain, about our biological evolution and physical world, about culture, about therapy. This book, then, was undertaken in the interests of the repainting process.

The reader is put on notice, however, that this modest volume does not aspire to administer the final brush strokes. Rather, it is intended to stimulate research, thought and discussion that will, over time, culminate in a fully developed theory of art therapy that is firmly grounded in the latest scientific evidence.

In brief, the contents are as follows. Chapters 1 and 2 seek to prepare the canvas by looking at the relationship between art and science and by delineating the role of research in painting a new picture. Chapters 3 and 4 attempt to begin the painting process by blocking in the background. Chapter 3 does this by touching on some basic issues that science is currently illuminating which relate to some of art therapy's assumptions. Chapter 4 examines what research is showing us about the limitations and failures of traditional approaches to psychotherapy. Filling in the fore-ground is the work of Chapter 5, which presents some of the scientific evidence for the benefits of art making, and of Chapter 6, which investigates the current state of art interpretation. Chapter 7, the last chapter, takes tentative steps toward completing the picture by sketching in the outlines of an integrated composition. In so doing, it discusses some of the implications of what has preceded and indicates further areas to be

explored. Finally, the book concludes with an afterword that issues a call for collaboration in the repainting process and an appendix that presents some ideas for incorporating the scientific perspective in art therapy education and practice.

Notwithstanding my use of a painting metaphor, it should be noted that a good deal of the material presented applies to all the therapeutic arts and thus may be of interest to arts therapists from different disciplines. Likewise, other health professionals interested in the creative therapies may find something of value here. For these readers, who might desire background information to supplement this book, Maxine Junge's (1994) *A History of Art Therapy in the United States*, Diane Waller's (1991) *Becoming a Profession: The History of Art Therapy in Britain 1940–82* and Judith Rubin's (1999) *Art Therapy: An Introduction* are recommended.

Art and Science

I grew up in the pre-feminist 1950s when women went to college to get their 'MRS' degree and were not particularly welcome in the world of science. How odd it seems to find women today rejecting science – for supposed feminist reasons. In a recent article titled 'A Discussion of Art Therapy as a Science', art therapy clinician and researcher Linda Gantt (1998) includes gender issues among the influences that may lead the predominantly female practitioners of art therapy to eschew science. For her part, Gantt declares: 'I am not persuaded that the scientific method is or should be the sole province of men, and I am not prepared to give up my little corner of it' (p.6).

Yet articles such as Gantt's indicate that the winds of change are blowing. During the quarter of a century that I have been involved in art therapy, I have witnessed a progression from intense science phobia to a more attenuated form of this affliction. Slogans such as 'I'm a right-brained person in a left-brained world' (with the implication that the bearer is 'intuitive' rather than 'analytical') are being replaced with exhortations to do more research (e.g. Tibbets 1995; Wadeson 1992), if for no other reason than to convince the left-brained rest of the world that art therapy has value.

It seems to me that it is high time for art therapists as a group to take another step forward and acknowledge that the so-called 'right brain' and 'left brain' work together, that it takes two halves to make a whole. Taking a look at the relationship between art and science will help to illustrate this point of view.

Comparing art and science

Art and science each involve specialized processes and products. On a superficial level the differences seem to clearly differentiate these major branches of knowledge; however, closer inspection reveals a number of congruences. Prominent among these is the desire for order and meaning that is an underlying motive for both creating art and pursuing science. The words of distinguished biologist Edward O. Wilson (1996) underscore this point:

> The role of science, like that of art, is to blend proximate imagery with more distant meaning, the parts we already understand with those given as new into larger patterns that are coherent enough to be acceptable as truth. Biologists know this relation by intuition during the course of fieldwork, as they struggle to make order out of the infinitely varying patterns of nature. (Wilson 1996, p.129)

Another area of overlap between art and science is the mutual reliance on creativity. Researchers attempting to understand the creative process have not limited their focus to artists but have also included scientists in their studies (e.g. Vernon 1970). Although there has been recognition that creativity is not necessarily the same for different fields (for instance, psychologists Feldman, Csikszentmihalyi and Gardner [1994] have developed a model of creativity that encompasses the individual, the domain of knowledge and the domain's field or social system), few investigators would dispute that creativity has aspects which can be generalized across disciplines.

It is also apparent that art and science can relate through the application of one to the other. Both a *science* of art and an *art* of science are conceivable. Concerning the former, various aspects of art supply the phenomena for scientific investigation. Concerning the latter, science can be shown to have its esthetic side. For example, zoologist Richard Dawkins, in his recent book *Unweaving the Rainbow* (1998), likens the 'spirit of wonder' that inspires great poets to the drive which animates great scientists. Similarly, the characteristics of a work of art as delineated by pioneer art therapist Edith Kramer (1993, p.50) – 'economy of means, inner consistency, and evocative power' – can be said to describe a well-crafted scientific theory.

Finally, even what is considered to be a major distinction between the two fields – the subjective versus the objective stance – begins to blur upon closer inspection. Art often depicts the outer world along with the inner, and science not only investigates subjective experience but also, as science writer George Johnson (1995) has extensively documented, provides abundant indications that objectivity is a goal that can never be completely realized. Subjective and objective viewpoints, then, exist on a continuum along which art and science approach each other. This suggests that the underlying cognitive processes involved in art and science are more similar than otherwise – a suggestion that is supported by creativity studies and by the efforts of philosopher Paul Churchland (1995). After reviewing recent results from neuroscience and artificial intelligence, Churchland concludes that 'from a neurocognitive point of view, the differences [between art and science] are superficial' (p.297).

Thus it appears that art and science have more than a speaking acquaintance. Further, it seems that a union of the two is entirely possible – if we can but be convinced it is worth the effort to bring them together.

Uniting art and science

Biologist Wilson, referred to above, emerges as a persuasive advocate in *Consilience* (1998). He argues for the essential unity, or concurrence, of all knowledge and, in the process, makes the case for conjoining art and science. Furthermore, he takes pains to reassure us that this undertaking will not prove destructive to art. Addressing an oft-stated concern of those in the humanities, he points out that although science is initially reductionistic (i.e. seeks the smallest building blocks of the material world), its ultimate goal is synthesis (i.e. a reassembly of the parts). He also makes it clear that the coming together of art and science which he envisions is not a hybridization of these two branches of knowledge but a collaborative venture in which the contributions of each can be readily distinguished. (Using language familiar to therapists, we might say he supports a 'marriage' that preserves the identities of the partners rather than one that fosters a dysfunctional enmeshment.)

In developing his argument, Wilson first establishes the significance of science. Comparing members of prescientific human communities to fish in a shadowed pool, he makes the following eloquent statement:

Wondering and restless, longing to reach out, they think about the world outside. They invent ingenious speculations and myths about the origin of the confining waters, of the sun and the sky and the stars above, and the meaning of their own existence. But they are wrong, always wrong, because the world is too remote from ordinary experience to be merely imagined. (Wilson 1998, p.45)

The 'merely' before 'imagined' in the last sentence of this passage needs to be understood in context. Wilson's poetic language reveals that imagination is something he prizes. His point is, however, that unaided imagination can mislead us. It is a point bolstered by the writings of the late Carl Sagan, noted astronomer and popular science writer. In one of his last books *The Demon-Haunted World: Science as a Candle in the Dark* (1995), Sagan laments at length modern scientific illiteracy and the superstition and pseudoscience that are prevalent as a result. Wilson and Sagan appear to concur that what was true in the past is true now: without science, we construct a fantasy world.

Wilson strengthens his thesis by emphasizing that consilience is a growing trend throughout science. The natural sciences have engaged for some time in overlapping endeavors as evidenced by such specializations as molecular biology, physical chemistry and biophysics. More recently, a similar collaborative generation of knowledge can be detected in the behavioral and social sciences; for example, evolutionary psychology is a new area of study that has arisen as a result. Although expanding this trend to the humanities seems more challenging, there is historical precedent for making the attempt. Wilson cites the great Enlightenment philosopher Francis Bacon as one who championed this cause and notes that Bacon viewed the humanities, including the arts, as ways to develop and express knowledge gained through science.

The foundation laid, Wilson confronts the challenge of exploring the link between the sciences and the arts. As with other areas of knowledge, a primary feature of this link is using scientific methods, discoveries and principles to elucidate and interpret. Wilson states: 'If the brain is ever to be charted, and an enduring theory of the arts created as part of the enterprise, it will be by stepwise and consilient contributions from the brain sciences, psychology, and evolutionary biology' (1998, p.216). He

adds that humanities scholars must be involved in the collaboration if creativity is to be fully comprehended.

Again, Wilson's point is supported by the work of others – in this case, work that indicates applying science to art is both feasible and meaningful. Barkow, Cosmides and Tooby (1992), pioneers in evolutionary psychology, introduce an overview of research in environmental esthetics with these remarks:

> Given that many of the criteria that govern our esthetic preferences are complex and not open to introspection, it is perhaps not surprising that they should appear inexplicable and idiosyncratic to us. Yet a growing body of evidence suggests that this impression is illusory. Although the study of environmental preferences is still in its infancy, it already appears that our esthetic preferences are governed by a coherent and sophisticated set of organizing principles... If these chapters are any indication, the study of environmental preferences may prove to be yet another common ground upon which science and art will meet. (Barkow *et al.* 1992, p.553)

Numerous other studies support Wilson's point as well. A fuller discussion of scientific research relevant to art will be undertaken in Chapter 5.

But what I find most heartening about Wilson's thesis is his view of the contribution the arts can make to consilience – a view that needs only the confirmation of our own experience. He suggests that the arts provide a much-needed balance for the knowledge gained through the exercise of our intellects, knowledge that tends to alienate us from the rest of nature and to create feelings of anxiety. The findings of science can intensify a painful awareness of our less than perfect temperaments, of our finite existence and of our chaotic environment. These findings improve our chances of survival on life's journey but art soothes us, supports us and inspires us along the way.

Integrating art and science in art therapy

Science, then, in partnership with art, has much to offer art therapy. It offers a means to establish proof of worth. More important, it offers the prospect of revealing the secrets of art and art making and, as a consequence, of developing a true theory of art therapy – rather than relying on theory borrowed from psychotherapy. As art therapist Judith Rubin

(1984a) has emphasized, we need to build a theory of art therapy that arises from the discipline itself. If we do otherwise, we run the risk of forcing it into ill-fitting molds. Further, as I will show in Chapter 4, prevailing psychotherapeutic theory is in trouble and thus offers at best a shaky foundation on which to build.

It takes more, however, than presenting a reasonable case for a change to occur. Barriers that stand in the way of change must also be confronted. Science neglect, a legacy of art therapy's founders, is a major hurdle that could be more easily gotten over if it were not for additional factors. This barrier to change has undoubtedly been reinforced by four anti-science influences that Gantt (1998) described in her previously mentioned article on art therapy and science. A quick review of these influences will reveal the extent of the problem.

The first influence has already been noted and involves matters of gender that can color the attitudes of the members of a largely female profession such as art therapy. Because men have historically dominated science, feminists tend to view it with suspicion, and women in general are often convinced it requires skills they are incapable of learning. The second influence has to do with the postmodernist philosophy that pervades the humanities, one of the pillars on which art therapy stands. Viewing all knowledge as relative, postmodernism denies that science has any special claim to truth. The third stems from the popularity of pseudoscience – practices such as astrology that have the superficial appearance of science but do not hold up under scientific scrutiny. The last negative influence concerns the perception of science as a destructive enterprise that produces horrendous weapons of mass destruction, various kinds of environmental toxins and assorted other evils.

Not all of these influences are difficult to overcome. Some can be countered by education. Others will be largely resolved with patience and time. Gender issues will dissipate as more art therapists become involved with and begin to appreciate the beauty and utility of science. Likewise, postmodernism will decline when people tire of its abstruseness – and when the next intellectual fad comes along (let us hope that it will be more science friendly). Upgrading the image of science can be accomplished by pointing out its positive achievements (e.g. medical advances) and by emphasizing that the worth of the scientific process is independent of its abuses.

The remaining influence, pseudoscience, can also be addressed by education, but it is unlikely to give way very easily. Employing an evolutionary perspective, Dawkins (1998) suggests why this is so. As he explains it, we come into the world gullible, ready to accept what those who speak with authority tell us. During childhood, this gullibility serves us well; it helps us quickly absorb information needed for survival – whether about how to avoid predators on the African plains of our remote ancestors or about the dangers of crossing a busy street in the metropolises of today. Later, particularly for mature members of complex societies, such credulity becomes more liability than asset, yet it is hard to give up. (Indeed, who knows better than therapists that childhood is something from which we never completely recover!)

Nevertheless, in spite of tradition, in spite of negative influences, I feel optimistic about art therapists learning to integrate art and science in a way that will advance the profession once they fully appreciate the need. Much of the rest of this book attempts to bring home this need by pointing out issues that require further investigation and assumptions that, according to what science now tells us, should be abandoned or modified. But before proceeding, I must address a neglected issue. I must clarify what I mean by 'science'.

In the context of this book, the term 'science' is interpreted broadly. It refers to both a method and a body of knowledge that goes beyond the average creative arts therapist's acquaintance with psychotherapeutic concepts. The method can be defined succinctly as 'the observation, identification, description, experimental investigation, and theoretical explanation of phenomena' (*The American Heritage Dictionary*, 1992, p.1616). The relevant body of scientific knowledge is taken to include the research of such disciplines as anthropology, evolutionary biology, ethology, medicine, neuroscience, sociology, psychology and the physical sciences. In short, the view of science I am advocating has much in common with Wilson's consilient perspective.

Although my interpretation might sound grandiose, let me stress that I am not proposing that those who use art therapeutically spend most of their adulthood in school, cramming their heads with scientific facts and procedures in order to do their job. To be sure, the hard work of solid theory building – for which this book is only an introduction – requires education well beyond the usual art therapy training. But the modifications

in training and practice necessitated by incorporating more science into art therapy should be relatively modest for the average practitioner. (See Appendix for some recommendations concerning these changes.)

The Role of Research

Research can be exciting; it can also be frustrating, boring, labor intensive and – sometimes – risky. We must carefully prepare before undertaking any research project. We must equip ourselves with the necessary tools and construct a thoughtful plan. Moreover, we must research the relevant literature in order to avoid 'reinventing the wheel'. It is a major premise of this book that art therapists need to become more aware of existing studies. It is also a premise that, as art therapists become more science minded, they will increasingly conduct well-planned investigations and the excitement generated by what is discovered will more than compensate for any difficulties along the way.

Research and the science-minded art therapist

Being science minded means being research minded. It means doing research, evaluating research and applying the research of others. But before taking action and along with acquiring an increased understanding of science and its methods, art therapists must answer a number of questions for themselves: What are the boundaries of research? Which methodologies should we use? What research questions should we pursue? How do we go about incorporating research from other disciplines?

It should also be kept in mind that, as mentioned in the preceding chapter, there is more to be gained from research than proving art therapy's worth to the rest of the mental health world. Indeed, framing the motivation in this way may even be self-defeating. Writing in a special issue on research in the journal *Art Therapy*, Lynn Kapitan (1998) suggests that approaching research from this perspective promotes 'an identification with powerlessness', and she offers the more potent image of research as 'a contemporary form of an ancient hunting and gathering

tradition' (p.22). Without a doubt, research is exploratory behavior that provides opportunities for gathering data pertinent to questions about art therapy and, hence, offers the means for nourishing and strengthening this developing field.

The boundaries of research

Even when research is broadly conceived (as it is here), it has its limits. Every form of human exploratory behavior does not qualify. Paul Leedy (1997), writing about research from a generic perspective, emphasizes this point. He states that research is more than the simple gathering of information, that some attempt to interpret the data must be involved. Thus, the process of writing a paper based on material gathered in the library should be considered 'information discovery' (p.4); it is not, technically speaking, research.

Those concerned with the creative arts therapies have also explored the boundaries of research, but have sometimes tended to be too inclusive. Art therapists Maxine Junge and Debra Linesch (1993) have defined research as 'structured inquiry' (p.63) – which implies an attempt to answer questions hitherto unanswered or to perceive existing data in a new light. This definition is still too broad, however. Psychiatrist Robin Higgins, in his handbook on research for creative arts therapists (1996), fortunately offers some needed refinement.

In particular, Higgins differentiates artistic endeavor – which could be considered structured inquiry – from what has traditionally been labeled 'research' and describes several points of cleavage. Artists create works that embrace ambiguity. They also frequently 'color' the facts in order to make a statement – which may resonate with others as truth, but which illustrates rather than validates general principles. Finally, artists want their creations to stand on their own and resist requests for explanation. These characteristics of the artistic process contrast with the aims of the traditional researcher who attempts to eliminate ambiguity, gather verifiable evidence and fit the findings into a larger explanatory framework.

Some have protested, however, that research in art therapy demands a non-traditional approach. For instance, Shaun McNiff (1998) has argued for a perspective that 'will encourage researchers to look carefully at the qualities of images and art therapy experiences without proclaiming that

one mode of inquiry is more scientific than another' (p.87). He concretizes his view by suggesting that narrative case studies and experimental research designs are on a par, and by so doing begins to stretch the definition of 'scientific' beyond acceptable limits. Dance therapist Helen Payne, on the other hand, has offered her personal view of research in the arts therapies that seems general enough to cover some of the less conventional methodologies yet not so broad that it loses all meaning. Examining her own experiences in an article titled 'From Practitioner to Researcher' (1993), Payne states: 'As a therapist I understand research to be concerned with systematically checking out whether in fact the values and benefits I aim to generate through my practice are more than simply my wishful thinking' (p.17).

Payne's generous definition seems largely consistent with eight charac-teristics of research methodology delineated by Leedy (1997):

1. Research originates with a question or problem.

2. Research requires a clear articulation of a goal.

3. Research follows a specific plan of procedure.

4. Research usually divides the principal problem into more manageable subproblems.

5. Research is guided by the specific research problem, question, or hypothesis.

6. Research accepts certain critical assumptions.

7. Research requires the collection and interpretation of data in attempting to resolve the problem that initiated the research.

8. Research is, by its nature, cyclical; or more exactly, helical. (Leedy 1997, p.5)

This precise definition encompasses the full spectrum of research pro-cedures and provides a foundation for considering the relative merits of different research paradigms.

Suitable research paradigms

Certain art therapists have argued that qualitative (subjective) rather than quantitative (objective) methodologies are more compatible with art therapy and are, therefore, the methodologies of choice. This has been the case in articles by Bloomgarden and Netzer (1998) and Junge and Linesch (1993) that recommend and describe various qualitative methodologies. Other art therapists, such as Gantt (1998) and Rosal (1998), have been equally persuasive in taking the position that both types of research are needed. In a sense, all are right. Qualitative research explores in depth, is theory building and, as Payne (1993) has pointed out, allows the practitioner and researcher roles of the arts therapist to operate simultaneously through the medium of action research and similar methodologies. But no developing field can afford to neglect either of the major methods of investigation. Quantitative research tests hypotheses in order to refine theory, provides a degree of generalizability not found in qualitative studies and offers a training ground for would-be qualitative researchers that assists them in recognizing when the boundaries of research have been breached.

Discussing research in education, Robert Slavin (1992) asserts: 'To ask which [type of research] is better is like asking whether a car or a boat is better. The answer, obviously, is that it depends on where you are going' (p.72). Thus, there are instances when qualitative methodology is more appropriate (e.g. studying the subjective experience of the artist) and instances when quantitative methodology must be applied (e.g. determining the graphic signs associated with a particular mental illness). These two types of research can also be effectively combined – as would be desirable when investigating the experience and products of artists afflicted with a particular mental illness. A specific methodology that lends itself to such a combined approach is single-case research, which has been advocated by several creative arts therapists (Aldridge 1994; Diamond 1992; Rosal 1989). This type of research can be easily integrated with clinical practice and can accommodate qualitative assessment of the case along with objective measures of progress that are relatively 'user friendly'.

Much of art therapists' distaste for quantitative research probably stems from inadequate education in scientific methods and the misunder-

standings that result. Linda Gantt (1998) has indicated that art therapists are misguided when they shun research employing statistics. She states:

> I think more art therapists would have respect for the use of statistics if they really understood that they do not violate any of our cherished principles. For example, because art is a concrete object it is possible to study it from many different perspectives. While we might choose to measure it on a numerical scale one day, we can come back the next and do an unpacking of its symbolic content. (Gantt 1998, p.9)

Indeed, if artists can tolerate the idea of statistical studies in regard to art making (and research reported in the journal *Visual Arts Research* – published by the University of Illinois School of Art and Design – suggests that at least some of them can), then it seems that art therapists ought to be able to tolerate such research as well.

Nevertheless, if qualitative methods of research are easier and more appealing to art therapists, one might wonder why we should force the issue. Aside from the health of the field, the reason is that it is so easy to be misled by that 'wishful thinking' mentioned by Payne when we use subjective methods alone. Psychologist Stuart Vyse (1997), in *Believing in Magic*, cites studies that reveal how easily our expectations can distort the facts. In one such study, members of two groups of people were given identical astrological profiles. Before receiving the profiles, all participants were asked for their birth dates, but one group was asked to give more detailed birth information than the other. The result was that participants from both groups thought the horoscope accurate. However, those who had given more detailed information found it more accurate than those who had not. Apparently, expectations of an accurate astrological reading were enhanced by the illusion that the horoscope was being more precisely constructed. And what people expected, they found!

Closer to home, art therapist Rachel Garber (1996) illustrates the problem as she recounts her own professional development. 'I recall my early suspicion of research methodology... I had faith in my subjective, intuitive understanding. Imagine my dismay at discovering that this understanding based on my subjective observations was sometimes simply wrong when assessed with more objective methods' (p.86).

Perhaps even more to the point, there is the case of psychoanalysis. Freud used introspection and the subjective reports of his clients as the

data for developing and substantiating his theory of psychoanalysis. His notions were brilliant and persuasive, but as will be discussed in depth later (see Chapter 4), recent research in neuroscience, psychology and biology is proving them mostly wrong (Gazzaniga 1992; Hobson 1994; Pinker 1997b; Wilson 1998). Moreover, researchers Lynn and Vaillant (1998) recently revealed that Freud did not follow his own guidelines for responsible therapeutic method. By presenting detailed historical data, these researchers have shown that Freud frequently failed to preserve confidentiality, anonymity and neutrality with his clients. Since the latter two guidelines were essential for garnering the evidence to support his clinical hypotheses, a strong case is made that Freud never really tested his theories. The bottom line is that qualitative research is more subject to misinterpretation and more difficult to apply with rigor than quantitative methodology.

But whatever methods are employed (quantitative or qualitative) replication of studies and conducting series of related studies are very important. We prove little with a single study, the results of which may be nothing more than an artifact of extraneous variables or a misinterpretation due to a limited perspective. Compelling evidence comes from an accumulation of findings that point in the same direction.

Important research questions

Much of the still small but growing body of research in art therapy is focused on the product, on the meaning of the form and content of art images. Author and clinician Cathy Malchiodi (1998, p.82) recently posed this question: 'Why has the field of art therapy spent most of its energy conducting research on the meaning of images rather than on understanding the process it takes to make them?' Her purpose in raising this issue is not to supply an answer but to point out deficiencies in art therapists' research efforts. She emphasizes that while we should continue to investigate the products of art therapy (their meaning, after all, is important), it is imperative for the advancement of the field that we amplify our efforts to include explorations of the art-making process.

A series of related queries have especial significance for art therapy practice. What is the impact of different kinds of imagery on the creator? What are the most beneficial ways of approaching art making? What is the

role of the art therapist in facilitating the making of therapeutic art? What lasting effects does the client carry away from the art-making experience? What does the client value most about the art-making process? Questions such as these supply the foci of an expanded research agenda.

Research from other disciplines

However, we are in danger of begging fundamental issues unless we lay some groundwork first. In an earlier piece, Malchiodi (1995) suggested that we need to address a couple of important assumptions before we can do meaningful research. Framed as questions these assumptions become:

1. Is art making inherently therapeutic?

2. What does an art therapist offer that another clinician is unable to provide?

The good news is that there is considerable fresh research from other disciplines that can help us obtain at least tentative answers to these two questions (and by the end of this book, some answers along these lines will have been offered). The (possible) bad news is that the answers could turn out to be different than some of us might wish.

In any event, art therapists need not feel discouraged by the prospect of facing an overwhelming research agenda. Various branches of the sciences – in conjunction with art therapy's own developing body of research – can supply findings that will help us sort out what art therapy is and should be about. In order to illustrate this point, the next chapter, and much of the remainder of this book, presents applications of knowledge from a variety of disciplines that clarify issues relevant to art therapy and point the way toward eventual answers to all the questions posed in this chapter.

Further, important research advances can be made by art therapists teaming with other health professionals in order to produce broad-based studies of considerable rigor. Indeed, Malchiodi (personal communication, 10 October 1999) is among those few art therapists who are currently involved in such pursuits.

Illuminating Basic Issues through Recent Findings

With increasing rapidity, the mysteries of life are receding before the advance of science. These are indeed exciting times. A difficulty remains, however. Science is shining light into previously dark corners, yet exciting as this process is, there can be reasons to resist the light. A large part of the appeal of the arts is attributed to the mystery they embody. How do we reconcile this with the 'need to know' of science? Science itself has evidence to present that can assist us with this and other puzzling matters.

The lure of the mysterious

My cat, on the way out of the room on pressing business, suddenly stops and makes a quick detour. He has spied the half-open door to a closet that is usually kept shut and jumps inside to make a quick inspection before continuing on his way. It is in his nature to feel compelled to investigate the unknown, and it is in our natures as well. Indeed, it is so much a part of us that it even seems to inform aspects of our esthetic response. Evidence collected by Stephen Kaplan (1992), a researcher in evolutionary psychology, indicates that people prefer landscape scenes that provide a hint of mystery. That is, we prefer scenes that offer the promise of new information if explored, a preference that undoubtedly had survival value for our hunter-gatherer forebears.

E. O. Wilson (1998) extends this evolutionary perspective to the arts as a whole, which 'nourish our craving for the mystical' (p. 232). Emotionally, he believes, we are still back in the Paleolithic era. This is a reasonable assumption because on an evolutionary timescale our brains have had insufficient time for significant change. For our distant ancestors, life was a

daily struggle with many mysteries. These were held at bay by a smattering of knowledge, cautious exploratory behavior and attempts to appease and control through ritualistic use of the arts. Whereas a robust respect for the unknown was obviously advantageous in that period of our development, this is less so today. The rapid pace of our technological progress dictates that we learn as much as possible about our world so that we can prevent ourselves from destroying the very ecosystem in which we live. Therefore, we can ill afford to be so enthralled by mystery that it becomes an end in itself – as appears to have happened in some quarters of the arts therapies.

Does this mean there should be less involvement in the arts from a societal point of view? The answer to this is decidedly negative for several reasons. One is that there are many other reasons (to be discussed later) besides the celebration of the mysterious for engaging in the arts. Another is exemplified by the work of Leonard Shlain. In *Art and Physics: Parallel Visions in Space, Time, and Light* (1991), he makes a case that the works of visual artists serve as symbolic harbingers of scientific advancements. Whether we accept this thesis or not, there can be little argument that art holds up a mirror to society that is an invaluable aid to understanding its cultural context.

The point to be emphasized here is that a stubborn refusal to let go of 'mystery' can hamper art therapy and the people involved in dispensing and receiving its services. The secrets of art and art making can and are yielding to scientific investigation. My experience has suggested a certain reluctance on the part of some art therapists to embrace this fact. Perhaps the realization that their reluctance stems from an ancient mind frame will help them to let go.

Consider the words of Hippocrates who 2500 years ago advocated the application of scientific methods to medicine: 'Men think epilepsy divine, merely because they do not understand it. But if they called everything divine which they do not understand, why, there would be no end of divine things' (Sagan 1995, p.8). The message is clear. We need to support our conclusions with solid evidence, and we should not be quick to assume that we are in the presence of the ineffable when the evidence is not immediately available.

Of mind and matter

One area of investigation where evidence is becoming increasingly available has to do with mind–body unity. Confirmation by modern science of this age-old notion is exciting news for those art therapists involved in holistic practice. But what, in practical terms, does this mean? As explicated by neurologist and psychiatrist J. Allan Hobson (1994), it means first and foremost mind–brain unity. That is, the mind is a function of the brain and is inextricably tied to it. Or, in the words of Rodolfo Llinas, chief of physiology and neuroscience at the New York University School of Medicine, 'Our brain is us' (Koglin 1999, p.D11). The brain pulls the body's strings, and thus art therapists need to examine the extent to which the mind function of the brain can influence the rest of the body. Since art therapists deal primarily with imagery, I will focus on this aspect of mental activity here. (I will return to the topic of mind–brain unity in the concluding section of this chapter.)

There are definite signs that images have power that can be harnessed. Even without the benefits of science, we have long known that what we image can affect the body. Simple thought experiments provide convincing evidence. Picture your favorite food when you are hungry and you start to salivate. Picture your lover in sexy attire and you start to feel sexually aroused. But there is more we need to know for responsible practice. The conclusion that some have drawn – that the mind has the potential to override the laws of nature as they apply to the body – is not justified. The findings of neuroscience and the basic principles of physics do not support it.

First, there is solid evidence that the mind–body interaction is a two-way street. For example, structural abnormalities in the brain leading to an imbalance of neurochemicals have been implicated in the disordered thinking of schizophrenia ('Brain Imaging' 1997b). Second, what initially seems a triumph of mind over matter can usually be shown to be otherwise. Some years ago, a number of my creative arts therapy colleagues were enticed by the fire-walking workshops that were ubiquitous at the time. After participating in a lengthy preparatory session that included imaging something cool (such as 'cool moss'), they were able to walk across a patch of red-hot coals unscathed. But anyone can do this – with or without the special imagery and preparation. Physicist Graham Phillips (1994) has explained how this works. Some natural materials

transfer or conduct heat better than others. Metal is a very good conductor, wood is a relatively poor conductor, and hot coals are even poorer conductors. Thus it is possible to take several quick steps over a bed of coals without getting burned. Mind over matter does not enter into it!

Neuroscience can help us understand the reality-based impact of mental imagery. Recent research (see Pinker 1997b for a review) has shown that the visual cortex of the brain is activated in a similar way by imagery from either the external world or the imagination. It seems logical, then, that our bodies respond to mental images as though they were things actually seen. Conversely, it can also be inferred from this that the effects of mental imagery are probably limited to the range of our visually stimulated responses.

This is not to say that what we see cannot have considerable impact. For example, a study of patients recovering from gall bladder surgery suggested that pleasant scenery speeds recovery (Smith 1997). Half of the 46 patients in the study were in rooms that afforded views of trees while the other half could see only a brick wall from their windows. Patients in the rooms with a view required fewer painkillers following surgery and left the hospital sooner. As in the fire-walking example given above, we must refrain from extravagant claims based on this study. Ancient wisdom and modern science tell us that mind and body are one. Continuing to pay attention to new findings about the mind and its biological source – the brain – can eventually clarify what this means.

Comprehending the mind

There is more to know about the mind than its ability to create and react to mental imagery. The past decade has produced a host of books about the brain and the mind. Some of these concentrate on how brain activity results in mental functioning (e.g. Churchland 1995; Kosslyn and Koenig 1995). Others focus on evolutionary processes as an explanatory framework (e.g. Calvin 1996; Gazzaniga 1992; Pinker 1997b). Still others attempt to explicate the phenomenon of consciousness (e.g. Chalmers 1996; Dennett 1991; Hobson 1994). These works review the burgeoning research in the neurosciences and other relevant disciplines and draw conclusions from it. Together they document why the 1990s have been

called the 'Decade of the Brain' (Pinker 1997b, p.24) and why the resultant findings are so worthy of our attention.

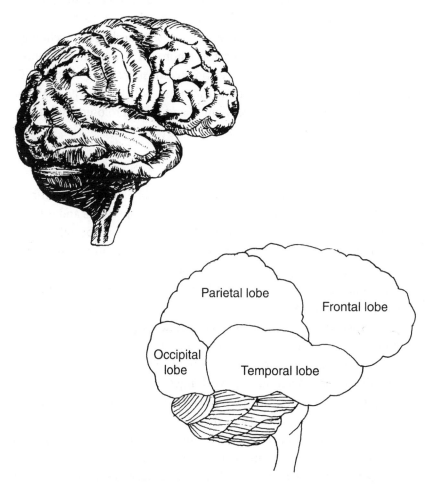

Frontal lobe: Concerned with planning, abstract thought and foreseeing consequences of actions.

Temporal lobe: Includes centers for hearing, memory and language.

Parietal lobe: Processes and integrates sensory information; responsible for body image.

Occipital lobe: Involved in visual perception and recognition.

Figure 3.1 Major regions of the cerebral cortex

It is not within the scope of this book to give a detailed review of the material presented in this important literature. A cursory summary will have to serve; the reader is encouraged to do further reading in cited works. Even though it seems obvious that breakthroughs in our understanding of the mind have relevance for those of us dealing in psychological matters, the connection between this improved understanding and art therapy will be underscored and elaborated in succeeding chapters. Two aspects of current thinking about the mind will be briefly dealt with below: the evolutionary origins of mind and the neurological substrate of mental activity (also see Figure 3.1).

The evolutionary origins of mind

With some modern refinements, Darwin's theory of evolution through natural selection is accepted as a virtual given by biologists and is used to inform and guide their work. It is also beginning to be taken up by psychologists as a means to enlarge their understanding of the human mind. It is able to do this by explaining how such a complex organ as the human brain could have arisen and by illuminating some of the probable reasons our brains induce us to do some of the things we do.

In a nutshell, the basic theory is as follows (Pinker 1997a, 1997b; Wilson 1998). Each generation of a particular type of organism has variants. Some of these are better adapted to their environmental niche than others and therefore survive longer and reproduce more. As a consequence, the better adapted variants of a specific population outnumbered and gradually replaced the other members. By tiny increments over the eons, this process – called 'natural selection' – can produce organisms that are vastly different from their distant ancestors.

Two latter-day developments have refined Darwin's theory. One is the discovery of genes. Genes are those molecular structures housed in our bodies that are passed from one generation to the next. They are replicators – substances capable of duplicating themselves – and they are the engine that drives evolution (Dawkins 1989, 1998). In addition, they provide us with an explanation for why not everything about humans is of obvious survival value. 'The ultimate goal of a body is not to benefit itself or its species or its ecosystem but to maximize the number of copies of the genes that made it in the first place' (Pinker 1997a, p.93). Genes build

brains that produce minds, but these minds have goals that go beyond the spreading of genes. Nevertheless, we can gain a better understanding of our minds by asking what selective advantages might have resulted from our genes building particular behavioral predispositions into our brains. For example, altruistic behavior may not directly benefit an individual and may actually prevent the propagation of that individual's genes. It does benefit the individual's community, though, and thus contributes on the average to the survival of community members.

The other important development that impacts Darwinian theory is the emergence of complexity theory – this was pioneered by biologist Stuart Kauffman and physicist Murray Gell-Mann (Johnson 1995; Pinker 1997b). This theory suggests that matter has innate properties which promote the organization of complex systems. For evolution to begin, self-replicating molecules must have arisen somehow. For it to continue, organisms must have greater tendencies to remain whole than to disintegrate into their parts. Complexity theory, then, fills in some gaps not explained by natural selection. Natural selection theory, on the other hand, explains how spontaneously occurring complexity developed into all the wondrous life forms that exist today.

The neurological substrate of mental activity

Since the nineteenth century, evidence has been steadily mounting that the mind is the work of the brain. One line of evidence has involved progressive revelations concerning microscopic brain activity (Hobson 1994). Initially, it was found that varying electrical activity in the brain correlated with different mental states (i.e. asleep and awake). The detection of electrical signals generated by individual brain cells (neurons) followed, as did the discovery of the role of neurochemicals in the neuronal signaling process. These revelations resulted in the modeling of a plausible mechanism by which the brain could encode and act upon information. In other words: 'Once the idea of representation via electrically coded signals was accepted, emotions, memories, and all the exquisite and tortured states of our conscious existence could begin to be modeled in physical terms' (Hobson 1994, p.13).

Another line of evidence has tracked the functioning of the brain on the macroscopic level (Wilson 1998). Cognitive deficits and personality

changes displayed by people suffering from localized brain damage have provided clues which enable neurologists to map functions performed by different areas of the brain. Experimental brain surgery has contributed additional information. By electrically stimulating the cerebral cortex at different points during surgery, neurosurgeons have been able to evoke memories, sensations and muscular contractions from their patients (who remain awake during the procedure but experience no pain because the brain lacks pain receptors). Most recently, less invasive brain imaging techniques (e.g. PET scans) have been developed that are permitting scientists to view the living brain in action at ever finer degrees of resolution.

The results of microscopic and macroscopic investigations carried out by neuroscientists – a diverse group that includes biologists, neurologists, psychologists and empirically oriented philosophers – all point in the same direction. Taken together, they imply that not only is mind–body dualism an invalid concept, but that even to speak of mind–body inter-action creates an inaccurate impression. (Indeed, this is similar to saying that the stomach and its digestive processes interact with each other.)

An illustrative example from recent research is the breakthrough in comprehending the phantom limb phenomenon. In the past, a frequent explanation for the phenomenon was that sensations emanating from miss-ing limbs were really 'all in the mind'. Brain researcher V.S. Ramachandran (Ramachandran and Blakeslee 1998) has carried out a simple yet ingen-ious experiment pointing to less ethereal origins. Blindfolding an amputee and using a Q-tip, he stroked various parts of the amputee's body. As he suspected, touching certain places stimulated sensory experiences that seemed to originate from the phantom limb. He explains the mechanism thusly.

Half a century ago, experiments during neurosurgery showed that there is an image of the body mapped on the brain. This 'sensory homunculus' responds to stimuli from specific parts of the body and is distorted in several ways. It has greatly enlarged areas for those body parts that are most sensitive. It also has odd juxtapositions; for instance, the area corresponding to the genitals is immediately below the feet and the area responsive to the hand occupies a position next to the face. The impor-tance of this latter fact has lately been revealed by investigations employing contemporary brain scanning technology. Apparently, when a limb is lost,

intact body areas adjacent to its area in the brain begin to invade its space. Therefore, it is neither surprising nor merely a product of the imagination that, say, stroking the cheek invokes sensations coming from both the cheek and a missing hand (see Figure 3.2).

Figure 3.2 Artist's conception of the brain's 'sensory homunculus'

Still, full understanding of how neurons, neurotransmitters and patterns of electrical activity add up to mental functioning is yet to come. Speculations are plentiful, however, and E. O. Wilson (1998) has attempted to piece these together in order to formulate the outlines of a probable theory. A few of his conclusions will serve to convey some of the key aspects. These are summarized in the following paragraph.

What we think of as 'mind' appears to be conscious and unconscious streams of coded representations. These representations correspond to perceptions and the memory and manipulation of perceptions. The underlying process for sorting and retrieving sensory information is most likely vector coding, a means of denoting direction and magnitude. (An example of vector coding is the ability to identify a particular substance based on the degrees of sweetness, saltiness and sourness in its taste.) Consciousness, then, involves the parallel processing of a multitude of coding networks. Further, no individual stream of consciousness is in charge; that is, there is no 'executive ego'. Consciousness is simply (or not so simply) the aggregate of participating neural circuits at any given point in time. 'The mind is a self-organizing republic of scenarios that individually germinate, grow, evolve, disappear, and occasionally linger to spawn additional thought and physical activity' (Wilson 1998, p.110).

Stated another way, this explanation of the mind is consistent with the generally accepted concept of brain modularity. Today's brain scientists consider the brain to be composed of relatively independent modules, each with a specific set of functions, and discount the popular (and older) notion that the brain is centrally organized (Restak 1994). As are other ideas and findings generated by recent research, this view of the mind–brain is in conflict with central tenets of traditional psychotherapy theory. The implications for psychotherapy of our recent advances in knowledge are the focus of the following chapter.

Traditional Psychotherapy Theories

Their Limitations and Failures

During my early years as an art therapy practitioner, I was enthralled with schizophrenia. That is, I was deeply fascinated with this illness that manifested itself through bizarre verbalizations and behavior and which, I then believed, had its origins in unconscious mental processes. One of my more up-to-date professors had indicated that most modern psycho-analysts adhered to the position that a person needed to have a biological predisposition for schizophrenia to develop. Nevertheless, I was given to understand that psychodynamic issues were also a significant part of the etiology.

I read widely in the psychoanalytic literature on the subject of schizophrenia and was excited by what I found – such etiological explanations as individuals afflicted with this devastating disorder were stuck in the symbiotic phase of early development (largely due to faulty parenting) and, further, suffered from unconscious intrapsychic conflict over oral aggression (e.g. Silverman, Lachmann and Milich 1982). Anxious to translate these notions into action, I attempted to apply them in art therapy with several schizophrenic patients. I did this by trying to evoke a reparative experience of symbiosis through art interventions – principally, by drawing with the patient on the same piece of paper (Kaplan 1983). Although the patients appeared to enjoy this joint activity, I effected no cures. Indeed, to have done so would have run counter to what we now know or have good reason to suspect about the biological bases of schizophrenia ('Schizophrenia Update' 1995).

The example just presented is not an isolated one. Recent findings raise many questions about psychoanalytic theory and practice and about aspects of other traditional psychotherapeutic approaches as well. These findings indicate that we should, at the very least, thoroughly re-examine

the psychotherapeutic underpinnings of art therapy. Psychoanalysis (and the psychodynamic theories it has spawned), humanistic approaches and cognitive-behavioral approaches all have limitations and inaccuracies and all fail to provide an adequate explanatory framework for art therapy.

These are strong statements, and at this point you may be tempted to conclude that I presume too much. But let's look at some of the evidence. I believe it is sufficiently ample to justify my claims. In the succeeding sections, I briefly critique each of the three major categories of psychotherapeutic approaches – including the ability of each to justify the therapeutic use of art. In the final section of this chapter, I offer some thoughts on the future direction of psychotherapy.

The decline of psychoanalysis

Psychoanalysis is crumbling under the weight of criticism from sources both outside and inside the profession. Some of these criticisms have political and ethical rationales – for example, feminist objections to sexist proclivities in psychoanalysis. Important as such criticisms are, they are outside the scope of this book. The focus in the proceeding will be limited to evaluative judgements arising from the findings of scientific research and from developments in the philosophy of science.

Criticisms arising from research findings

Certain critics of psychoanalysis, such as neuropsychologist Michael Gazzaniga, have gone so far as to proclaim it dead. In *Nature's Mind* (1992), Gazzaniga points out that psychoanalytic theory may have made sense when Freud began formulating his ideas about a hundred years ago, but it does not do so today in the light of current knowledge. He also suggests that one of the reasons psychoanalysis has persisted is because it offers satisfying explanations for seemingly inexplicable behavior – not because there is scientific support.

Gazzaniga then holds up some cherished Freudian constructs for scrutiny. Chief among these is the Oedipal conflict. The argument against this particular construct runs as follows. If the Oedipal conflict is universal, it is logical to conclude that homicides involving kin occur with comparative frequency. Indeed, a common popular assumption is that people kill their kin more frequently than unrelated people kill each other. Yet this

assumption is not supported by crime statistics. Data collected in Detroit and Canada in the early 1970s suggest that only a very small percentage of murders involve consanguineous relatives. This finding, Gazzaniga stresses, is more consistent with the biological principles of natural selection than with Freudian theory.

Looking elsewhere, we find another primary tenet of psychoanalysis is called into question by the work of primatologist Frans de Waal (1996). He has marshaled an impressive array of evidence that suggests moral impulses are as fundamental to our nature as sexual and aggressive drives. He has documented many instances in which our closest relatives, the apes, mediate and resolve conflicts between individual members of their groups. In a similar manner, he has found that other aspects of human morality – sympathy and empathy, social rules, reciprocity – are foreshadowed by animal behavior. Further, zoologist Matt Ridley (1996) reviews many studies that support de Waal's findings.

Yet another blow to the Freudian superstructure is delivered by the work of science historian Frank Sulloway. In *Freud, Biologist of the Mind* (1979), Sulloway makes a convincing case that Freud was strongly influenced by nineteenth-century biology. Many of Freud's concepts – such as fixation, regression and the psychosexual stages of development – can be traced to largely outmoded biological theory. As an example, Sulloway contends that Freud's conception of psychosexual stages stems from the 'biogenetic law' formulated by nineteenth-century evolutionary thinkers. According to the biogenetic law, 'ontogeny recapitulates phylogeny'; that is, the development of an individual from embryo to adult (ontogeny) repeats the evolutionary history of the species (phylogeny). A reconstruction of Freud's view derived from his writings can be stated in brief. Recapitulation of history includes sexual history; this means that the developing child will tend to experience archaic forms of sexual gratification. The reasoning here seems sound if the biogenetic law holds. Unfortunately, it is not considered valid by today's evolutionary scientists.

But perhaps the most damaging evidence comes from the fields of neuroscience and genetics. The former undermines the Freudian theory of the unconscious and the latter plays havoc with psychodynamic etiological formulations. In regard to the neurosciences, sources mentioned in the previous chapter are representative of current thinking. Of these,

Churchland (1995) has succinctly summarized the case concerning the unconscious:

> The problem was not Freud's postulation of unconscious cognitive processes. Not at all. The vast majority of our cognitive activities take place at levels well below the conscious level. Rather, the problem was Freud's assumption that the *causal structure* of those unconscious cognitive activities is the same as the causal structure of our conscious cognitive activities. (Churchland 1995, p.182)

Churchland goes on to emphasize that the findings of neurobiology and other neurosciences indicate that the quality of unconscious cognitive activity differs greatly from conscious thought. Although the evidence of introspection suggests otherwise, this is most likely an illusion. What seems more probable, as Dennett (1991) has suggested, is that our introspective verbalizations serve to *construct* meaning rather than *uncover* meaning buried in the unconscious.

Further support for an unconscious very different from the one Freud postulated comes from dream research. Neurologist and psychiatrist J. Allan Hobson has specialized in this area. In *The Chemistry of Conscious States* (1994), Hobson documents the chemical changes in the brain that occur when we go to sleep and describes what happens during the dreaming process. Dreaming, which he likens to an organic psychosis, results from 'unpredictable and irrelevant stimuli' (p.94) that emanate from the dreamer's brain stem. This disorienting cacophony of images is then given some form by the dreaming individual's cerebral cortex in an attempt to restore order. It is this last maneuver that can produce personally revealing information, but, as Hobson points out, not necessarily more revealing than information that is accessible by simply talking to the individual. He states: 'Our new theory [of dreaming] allows us to dispense with Freud's distinction between the manifest content (which he demeaned and we consider valuable) and the latent content (which he extolled and we consider noise)' (p.94).

Turning to the findings of genetic studies, we discover reasons to question psychoanalytic and latter-day psychodynamic explanations of personality formation and, hence, mental illness. The evidence is piling up that heredity plays a substantial role in both cases. Through identical and fraternal twin studies, behavioral geneticists have found that about 40 percent of

personality is due to genes, another 40 percent to environmental influences, and the remaining 20 percent to measurement error (Sulloway 1997). An interesting aspect of these figures is that only 5 percent of the environmental influences on siblings has been found to derive from a common family environment. This suggests that parental behavior has considerably less impact than has been promulgated by psychodynamic theories. Support for this conclusion comes from several sources.

First, Sulloway (1996, 1997) has conducted historical research that indicates birth order has a significant impact on personality development. This impact interacts with, but is relatively independent of, the influence of relationships with primary caregivers. Subjecting other studies on birth order to meta-analysis (a statistical procedure for combining results from different studies) has supplied confirming evidence. Collectively, the studies show consistent birth order differences; for example, compared to later-born children, first-borns tend to be more achievement oriented and conservative while later-borns tend to be more unconventional and flexible (Sulloway 1997).

Second, journalist Lawrence Wright (1997) has summarized the results and implications of a large number of twin studies. One of the findings of these studies is that identical twins reared apart can be amazingly similar in their personality characteristics – in spite of very different family environments.

Finally, psychiatric research offers some compelling evidence. Brain imaging techniques ('Brain Imaging' 1997a, 1997b) are advancing the study of mental illness. Schizophrenia, depression, obsessive-compulsive disorder and Alzheimer's disease are among those illnesses being investigated by this revolutionary technology. These investigations reveal differences in brain activity, brain chemistry and, in some cases, brain structure that differentiate specific illnesses from each other and from normal mental states. Although these differences could conceivably have environmental causes, studies of familial disease patterns suggest that heredity plays a major role. For instance, the *Diagnostic and Statistical Manual of Mental Disorders (DSM-IV)* of the American Psychiatric Association (1994) reports: 'Adoption studies have shown that biological relatives of individuals with Schizophrenia have a substantially increased risk for Schizophrenia, whereas adoptive relatives have no increased risk' (p. 283). Further, genetics researcher Samuel Barondes (1998) and his colleagues are close to

pinpointing the genes responsible for manic- depressive illness through studies of the DNA of affected families.

For serious mental illnesses, however, concordance rates in mono-zygotic twins generally do not reach 100 percent. Nonetheless, the contribution from nurture as opposed to nature may be minimal. Due to factors during uterine development, identical twins are not as alike as we might suppose. It is possible for events during embryogenesis to result in only one of a pair of identical twins developing a heritable disease, as has been substantiated in at least one case of a hereditary physical illness (Wright 1997).

The preceding sampling of evidence from other disciplines attests to crippling defects in psychoanalysis. But it does not end there. Significant criticism comes from within its own ranks as well. Clinical researcher and internationally recognized Freud scholar Robert R. Holt, after devoting most of his career to psychoanalytic theory, considers it to be in crisis. In *Freud Reappraised* (1989), he declares psychoanalytic metapsychology to be virtually dead and the clinical theory to be in grave trouble.

Metapsychology, Holt explains, comprises the economic, dynamic and structural aspects of psychoanalysis. These major divisions of the theory have to do with, respectively, psychic energy, instinctual drives and the psychic structures of id, ego and superego. Summarizing the arguments against metapsychology made by himself and other clear thinkers associated with (e.g. Eagle 1984) or interested in (e.g. Sulloway 1979) psycho-analysis, Holt concludes that it contains many logical errors and that much of it originated in 'outdated physiology, anatomy, and early evolutionary biology' (1989, p.325). (The latter is a criticism that others have leveled, as we have seen.)

Holt informs us that the clinical theory, on the other hand, contains hypotheses having to do with origins, motives and patterns of behavior that are more directly related to clinical observation. Thus, unlike the propositions of metapsychology, much of it can be subjected to empirical testing – albeit not without a certain amount of difficulty in most cases. Holt stresses that the undertaking of such research, along with the necessary refining of the definitions and hypotheses of clinical theory, urgently needs to be done. He also states: 'We must go to a nonbehavioral realm, such as neurophysiology, to test a great deal of the most distinctive parts of the clinical theory' (1989, p.340).

Now, a decade after the publication of Holt's book, the situation is not much improved. So far, the neurosciences have had little but cold comfort to offer psychoanalysis, and definitive research from other sources has been hard to come by. The debate about the concept of repression, a cornerstone of Freud's clinical theory, is an illustrative example. Even though there has been considerable research from psychology that casts doubt on the validity of this concept (Holmes 1994; Loftus 1993), the existence of repression continues to be a hotly contested issue. One reason for this may be that the definition of repression needs updating, as proponent Horowitz (1994) suggests. Another is that, as Holmes (1994) indicates, it is difficult (if not impossible) to prove a negative, to prove beyond a shadow of a doubt that something does not exist.

Criticisms arising from philosophy

The last statement above takes on even greater significance when we note that it resembles a major criticism made by one of the great men of contemporary philosophy, Sir Karl Popper. Popper (1957/1998) has maintained that psychoanalysis is unscientific because its propositions *cannot be falsified.* He contrasts psychoanalysis with Einstein's theory of gravitation, a theory which has generated hypotheses that could be (but were not) disconfirmed when tested. He states that Freud's psychological theory, like Marx's theory of history, was built on evidence obtained by observation or induction. He avers: 'Induction, i.e., inference based on many observations, is a myth. It is neither a psychological fact, nor a fact of ordinary life, nor one of scientific procedure' (p.45). He declares that the deductive process of hypothesis testing is the only valid scientific method and indicates that psychoanalysts have failed to establish criteria for refuting psychoanalytic principles – a necessary step for carrying out the deductive process.

In short, Popper has argued that the inductive process amounts to a self-fulfilling prophecy and this means psychoanalysis is both untenable and untestable. But before we decide that Popper has sounded the death knell of psychoanalytic theory, we must consider whether he has possibly come to the right conclusion for the wrong reasons. Adolf Grünbaum (1984), a philosopher who has himself written an incisive critique of psychoanalysis, has taken Popper to task for a distorted view of inducti-

vism (in essence, qualitative research procedures) and for a misreading of Freud. Grünbaum has pointed out, as has Holt (1989), that the clinical (as opposed to the metapsychological) theory contains viable hypotheses. Take, for example, Freud's etiological hypothesis that homosexual conflict necessarily underlies paranoid delusions. Such a hypothesis is clearly testable by empirical means because any case of paranoia that does not fit the predicted pattern calls it into question.

Another school of philosophers (e.g. Ricoeur 1970) more or less sidesteps the issue of whether psychoanalytic theory has any claim to science. To them it is irrelevant. They consider psychoanalysis to be a hermeneutic discipline concerned first and foremost with the interpretation of meaning. Moreover, they view the methods of hermeneutics – originally developed to elucidate religious texts – as different from, but on a par with, the methods of science. There are numerous logical objections to this position that have been put forward by Grünbaum (1984) and by psychoanalyst Morris Eagle (1984). In regard to the hermeneuticists' notion that different interpretations and perspectives can be equally valid, Eagle remarks:

> If one…asks about *what* substantive matters the patient is being offered a perspective, whether it is possible to evaluate different perspectives, and, if so, on what basis it is possible to do so, the difficulties of the [hermeneutic] position become more apparent. (Eagle 1984, p.165)

Eagle goes on to designate parameters for an effective psychoanalytic interpretation, which include: '…doesn't conflict with what is known about human nature' (p.168). It is here that we come to the crux of the matter. It seems that at this point it is not so important whether we consider psychoanalysis testable. Certainly, there has been little effort on the part of psychoanalysts to make it so. What is important is whether or not its basic assumptions stand up under our present knowledge of human nature. Increasingly, it seems that they do not.

Keep in mind that Popper presented his objections to psychoanalysis as a science 40 years ago before as much was known about the brain and human nature as it is today. Had he been privy to this new information, he might have joined the ranks of philosophers such as Churchland (1995) who have based their criticisms of psychoanalysis on the findings of

neuroscience. Or he might have combined a contemporary perspective with logical analysis to make mincemeat of many Freudian concepts, as philosopher Colin McGinn (1999) has done. McGinn concludes his dissection of psychoanalysis as follows:

> It may be that for all of his hold on the twentieth-century mind, for all his modernism and atheism and skepticism, Freud's theories are just one more myth about human nature – an intoxicating mixture of truth, half-truth, and sheer invention. (McGinn 1999, p.24)

Although an eminent psychoanalytic scholar like Robert Holt has urged action and seems to caution us not to throw the baby out with the bath water, I think we are justified in wondering if the baby is really there!

Shortcomings of humanistic approaches

There is little doubt that the humanistic approaches to psychotherapy also have their problems when looked at from a scientific perspective. A loose collection of approaches with a shared philosophical base, they are perhaps best exemplified by the person-centered approach of Carl Rogers. Described as 'a "way of being" rather than a "way of doing"' (Corey 1994, p.263), this particular approach emphasizes creating a therapeutic climate that stimulates the client's natural propensities toward growth. More specifically, attitudes of empathy, genuineness and unconditional positive regard on the part of the therapist are considered to be not only necessary, but sufficient conditions for effective therapy. Furthermore, this is possible because 'to Rogers, individuals are basically rational, responsible, realistic, and inclined to grow' (Farber 1996, p.6).

Many have criticized Rogers's approach for what seems an overly optimistic view of human nature. (Indeed, as I write this, the newspapers are full of reports about a reasonably advantaged young person who took guns to his school in a quiet community not far from where I live and randomly mowed down his schoolmates. This incident – one of a string of similar incidents across the USA in recent months – testifies to a darker side of humankind.) But if common-sense evidence is not enough, there is the fact that the person-centered approach lacks adequate supporting research. Watson (cited in Farber 1996) reviewed the empirical evidence and reported equivocal findings. Corey (1994) has indicated that there has been little relevant research in over twenty years. Finally, the results of a

large-scale study undertaken by psychiatrist Irvin Yalom (1975) and colleagues to determine the effectiveness of encounter groups strongly suggest that the Rogerian attributes are necessary but not sufficient for positive therapeutic change.

Indications of what else might be needed for effective therapy is conveyed by a critique of one of Rogers's demonstration sessions. Psychologists Hayes and Goldfried (1996) analyzed the transcript of a session with a white South African psychologist called 'Mark' who was employed by the South African government. Written reactions to the session by both Rogers and Mark over a matter of several years were also taken into account.

The demonstration interview took place in 1986 before the demise of apartheid, and the problem presented by the young psychologist was the internal conflict between his values and the values of the system that employed him. Evaluating the efficacy of the session, Hayes and Goldfried remark:

> Although Mark felt more in touch with himself and more alive, a resolution of his conflict did not seem to have occurred. He remained in his position, working for a government whose values he did not support. There seemed to be an increase in Mark's self-acceptance but no clear understanding of what his values were and no plan for how he would live a life more consistent with those values. (Hayes and Goldfried 1996, p.371)

The evaluators also describe how a cognitive-behavioral therapist might handle the case. They indicate that such a therapist would first offer support, as Rogers did, but then move on to encourage some form of values clarification work and, ultimately, to promote a problem-solving stance. This is not to say that cognitive-behavioral approaches always have 'the key' (I will show in the next section that they do not), but that the evidence indicates that some form of cognitive work is required to complement the warmth and caring of the Rogerian approach.

It should be noted that some of the other approaches generally grouped with the Rogerian approach – gestalt, existential and phenomenological therapies – use a variety of techniques and interventions. Nonetheless, they share with person-centered therapy an emphasis on immediate experience. Furthermore, all these approaches fail to pay much

attention to biological factors, conveying the optimistic and often un-realistic message that, after removing some blocks to growth, we can recreate ourselves and be 'anything we want to be'. In short, humanistic clinicians emphasize nurture at the expense of nature and take the position that emotional disturbances arise from problems in living, not from mental illness (Garai 1987). Yet, as we have seen, recent neurological findings tell us that congenital brain abnormalities play a substantial role in psychopathology, confirming that mental illness definitely exists and cannot be ignored.

Inadequacies of cognitive-behavioral approaches

The cognitive-behavioral therapies seem the most in tune with modern science. They deal in measurable units of behavior that lend themselves to empirical testing, and they emphasize continuing research and evaluation. Further, psychotherapy outcome research has shown them to be effective in treating a variety of psychiatric disorders (Goisman 1997; Kingsbury 1995; Roth and Fonagy 1996). Indeed, the cumulative evidence in favor of these therapies is so strong and in support of other therapies is so weak that British psychologist Stuart Sutherland (1998) has been moved to conclude: 'There is no question that psychotherapists (with the exception of cognitive-behaviour therapists) do little or no better than a placebo' (p.216).

The faults of cognitive-behavioral approaches appear to lie more in what they fail to do than what they do. Psychologists Rosenhan and Seligman (1995) point out that these approaches have been charged with being superficial. They summarize the allegations by stating: 'Because behavior therapists and cognitive therapists restrict themselves to an analysis of the discrete behaviors and cognitions of the human being, they miss the essence: that individuals are wholes, that individuals are free to choose' (p.137).

But in spite of the proven usefulness of cognitive-behavioral appro-aches in removing certain symptoms, a more serious charge can be laid at their door. Like the other two groups of approaches, they are built on flawed foundations. In common with the humanistic approaches, they tend to overemphasize environmental influences. As a consequence, the principles of learning they espouse are not entirely supported by brain

science. Gazzaniga (1992) marshals evidence that indicates there are inborn constraints on learning that guide what a child learns. He also stresses that there are 'critical periods' during which certain skills are more readily acquired or adaptations readily made. For example, he explains that a child who suffers left-hemisphere brain damage at an early age can go on to learn language; however, after puberty there is little or no recovery from such damage and the ability to speak is lost.

Along these same lines, Pinker (1997b) presents another instance of limitations on learning. He argues that fears are adaptive mechanisms and discusses how some types of fears are more susceptible to conditioning than others as a result of our evolutionary heritage. The same person who is repelled by snakes and spiders – serious threats to our ancient forebears – may show little anxiety about the more realistic danger of speeding on today's busy highways. To back up his statements, Pinker cites a study which reported that Chicago schoolchildren said they feared lions, tigers and snakes most, rather than the more likely perils of a big city.

Finally, psychiatrists Shuchter, Downs and Zisook (1996) suggest that a major tenet of cognitive therapy lacks consonance with recent biological evidence. These clinicians, who have developed an approach called 'biologically informed psychotherapy for depression', maintain that the premise that learned cognitions are responsible for emotional disorders puts the cart before the horse. Although they acknowledge that distorted thinking can compound depression or contribute to transient unhappiness, they see depressive illness 'as driving cognition rather than vice versa' (p.156).

Thus it seems that the 'blank slate' notion of learning favored by behaviorists constitutes a seriously limited perspective. Further, it appears that replacing undesirable behaviors or attitudes with desirable ones is not always as straightforward as cognitive-behavioral therapists might wish.

Failure to explain the benefits of art making

So where does that leave us in regard to using any of the traditional psychotherapies as an explanatory framework for art therapy? Up a creek, it would seem. Art therapy had its origins in psychodynamic theory, and the psychodynamic model is still widely used by practitioners of all the

arts therapies (Johnson 1998). Yet this theory no longer appears to offer a satisfactory explanation for how the arts therapies work. Let's take a look.

Pioneer art therapist Edith Kramer's (1979, 1993) conception of sublimation has proved one of the more enduring explanations. Defining sublimation, Kramer states:

> It is a process wherein drive energy is deflected from its original goal and displaced onto achievement, which is highly valued by the ego, and is, in most instances, socially productive... Because ego strength and autonomy increase in the process, we surmise that a shifting of energy from id to ego occurs and that aggressive and libidinal energy is neutralized. (Kramer 1993, pp.68–69)

Art, she adds, differs from other forms of sublimation in that it retains some of the original drive energy in an unneutralized state. She argues that this gives creative activity both its exceptional power and its therapeutic utility.

Kramer's explanation is elegant and eloquently stated. But dependent as it is on discredited psychoanalytic metapsychology (Holt 1989), it can be seen as an unstable structure, easily toppled. This does not mean, however, that art making cannot substitute for more destructive behavior. Nor does it mean that Kramer's art-as-therapy approach has nothing to offer (we shall revisit this issue in Chapter 7).

Other psychoanalytically derived frameworks do not fare much better. For example, psychologist and drama therapist David Read Johnson (1998) describes a psychodynamic model of the creative arts therapies that relies on processes of projection, transformation and internalization. Divorced from their metapsychological and other questionable psycho-analytic trappings, these processes can be reduced to what Holt (1989) has called 'common-sense psychology'. It seems obvious that our artistic creations are to some degree reflections of us and thus have the potential for increased self-understanding, for experimentation with new ways of being and for change. Such common-sense understanding, however, does not do much to deepen our appreciation of the mechanisms or benefits of artistic endeavor.

One might be tempted to conclude that humanistic theories of creativity come closer to the mark. And to a degree, they do. Psychologist and art therapist Josef Garai (1987) has compared the humanistic perspective to other perspectives. He explains that other schools of psychological

thought – including psychoanalysis – subscribe to 'deficiency compensation' theories, whereas humanistic psychologists view creativity as a form of innate striving best described by 'dynamic–holistic' theories.

This sounds good but the trouble is that the humanistic perspective is too broad, too idealized. Perhaps in an attempt to compensate for reductionistic pathology-based conceptions, humanists go overboard in ascribing life-enhancing and even mystical qualities to the creative process. In the course of discussing humanistic theories, Garai states:

> Genuine creativity is characterized by an intensity of awareness, a heightened state of consciousness, and joy at the moment of execution. Creativity involves the whole person, with the unconscious acting in unity with consciousness. It is, therefore, not irrational but rather suprarational. It is a mystical experience in which the individual merges with the cosmos and in which total unity alternates with vast diversity. (Garai 1987, p.194)

The scientific evidence (to be reviewed in the next chapter) does, indeed, indicate that art making and creativity are inherent aspects of being human. It also presents a more focused and balanced picture than the humanistic view.

The cognitive-behavioral approaches, on the other hand, sidestep the issue altogether. Art making is entirely too interior a process to warrant special attention. Those art therapists who have adopted cognitive-behavioral approaches (e.g. Rosal 1996; Roth 1987) have done so without the help of a theory of artistic creativity supplied by these approaches. Further, the art produced in the service of these approaches has been largely schematic, a psychoeducational tool used to assist in detecting, developing and practicing specific behaviors and cognitions. Although I would not go so far as to rule this kind of image making non-art (as some have done), I think it is fair to say that it represents only a narrow band of the full spectrum of artistic expression.

Some thoughts on the future of psychotherapy

Since the rationale for therapeutic art provided by much of psychotherapy is either faulty or non-existent, we must seek support in other more scientifically grounded disciplines. But before presenting the current

evidence in relation to this issue, I will consider briefly some of the latest trends in psychotherapy.

One trend is toward combining approaches. For instance, in describing the current state of cognitive-behavioral therapy, psychiatrist Robert Goisman (1997) notes that cognitive-behavioral techniques are being combined with other treatments such as psychodynamic therapy and medication. To offer an explicit example, the biologically informed psychotherapy for depression devised by Shuchter *et al.* (1996) blends psychopharmacology with aspects of psychodynamic therapy, cognitive-behavioral therapy and interpersonal psychotherapy.

This combinative trend makes sense because each of the traditional classes of psychotherapies has something positive to contribute in spite of their deficits. A cursory review reveals that psychoanalysis reminds us of the impact of inborn tendencies on early development and, hence, behavior; that humanistic approaches give us guidelines for establishing respectful and effective therapeutic relationships; and that the cognitive-behavioral approaches emphasize the importance of ongoing research and evaluation, as well as indicating that solving discrete problems has therapeutic value. Although eclectic approaches to psychotherapy have been with us for some time, there seems to be an increasing recognition in the psychotherapeutic community that striving for 'purity' of approach is not in the best interests of clients.

Another recent trend in therapy is toward incorporating an evolutionary perspective. Psychotherapists Glantz and Pearce are in the vanguard of those attempting to apply evolutionary science to the practice of psychotherapy. Their book *Exiles from Eden: Psychotherapy from an Evolutionary Perspective* (1989) presents the interesting thesis that we are all hunter-gatherers under the skin. They build their case as follows. Humans lived as nomads for hundreds of thousands of years before the development of agriculture ten to twelve thousand years ago. From an evolutionary point of view, this change in lifestyle was too recent to have produced any alteration in our genetic propensities to behave and respond in certain ways – propensities that evolved to meet the harsh demands of the hunter-gatherer's world. This has led to a mismatch between genes and environment in contemporary society, and this mismatch, in turn, is responsible for much of the psychological distress that people suffer today.

Glantz and Pearce are not alone in their efforts. Psychiatrist Randolph Nesse (1997, 1998), among others, is working on developing a Darwinian framework for understanding psychopathology. Although Nesse does not agree that a new brand of psychotherapy is in order, he does agree that evolutionary science offers fruitful avenues for investigation. He remarks: 'What evolutionary principles can supply is a solid foundation for understanding human behavior that will eventually yield many new therapeutic insights' (p.7).

A final and important trend that should be mentioned involves setting aside theory to focus on what works. *A Guide to Treatments That Work* (Nathan and Gorman 1998), an impressive compendium that reviews the efficacy of treatments for all the major diagnostic categories, exemplifies this trend. In the book's preface, the editors state:

> One important aspect of this book is that it brings together psychologists and psychiatrists and also those whose main approach is psychosocial or psychopharmacological. There is surely competition and sometimes disagreement among these disciplines, but there is also much collaboration and agreement... We feel this is a genuine advantage and hope that this volume will be seen as an attempt to rise above interdisciplinary rivalries to arrive at a consensus based on hard scientific proof. (Nathan and Gorman 1998, p.xi)

Holt (1989) has pointed out that 'as sciences mature, schools wither' (p.214). We have not yet attained sufficient scientific knowledge to abandon all schools of psychotherapy, but the possibility of doing so is visible on the horizon.

Benefits of Art Making
The Scientific Evidence

In the previous two chapters, I have presented evidence that calls into question a number of the basic assumptions as well as the psychotherapeutic underpinnings of present-day art therapy. This is the background against which the benefits of art making and the interpretation of art must be re-examined. The present chapter will supply evidence which will have a bearing on the degree to which therapeutic art making can stand alone. The succeeding chapter will look at the evidence pertaining to how artwork may be reasonably interpreted. Fortunately, even though traditional psychotherapeutic theory in its current state offers little to elucidate the therapeutic mechanisms or meanings of art, we need not feel at a disadvantage. In what follows, it will be shown that findings from other disciplines have the potential to assist us in filling in these essential portions of the art therapy picture.

The evolutionary perspective

Pinker (1997b, p.210) points out that 'evolution created psychology' and hence culture. After a long period of resistance to Darwinism (for some reasons why, see Dennett 1995), social scientists have begun to accept this idea and to apply it in research – including investigations of the significance of art. As a consequence, both the appreciation of beauty and the creation of art are revealing their biological roots.

Our esthetic inheritance

I have noted previously (see Chapters 1 and 3) that aspects of esthetic judgements appear to arise from inborn tendencies. Evidence suggests that inherited predispositions influence preferences for specific types of

landscapes (S. Kaplan 1992; Orians and Heerwagen 1992). In addition, anthropologist Alexander Alland cites studies in *The Artistic Animal* (1977) that suggest there are universal standards for evaluating visual art. The former tendency can be explained as an adaptive attraction to environments with the characteristics of the African savannas that sustained our distant ancestors. The latter may stem from our forebears' need to hone perceptual capabilities in order to survive. According to Alland, the ability to discern artistic quality depends upon learning to activate an innate esthetic sensitivity that, once activated, may promote adaptation by functioning as a form of visual training. (Support for this supposition comes from the neurosciences, as we shall see.) In one study that Alland cites, for example, pictures of artwork in sets of three were shown to Yale University graduate students in art history and to a small group of Fiji islanders who were competent in crafts. Asked to indicate the order of preference for the artworks in each set, Fijians and students agreed with each other an astonishing 78 percent of the time!

Our understanding of the relationship between evolution and art is deepened when we reflect on possible biological motives for creating as opposed to appreciating art. Alland has explored the ancient origins of art making as has anthropologist John E. Pfeiffer. These two theorists have helped to set the stage for art historian Ellen Dissanayake's seminal writings. Before considering Dissanayake's important ideas, a brief examination of their conclusions is in order.

In Alland's (1977) view, art making is not the direct outcome of evolution but is a by-product of other developments with selective value. Chief among these developments are play and exploratory behavior, verbal communication and the capacity for perceptual discrimination – the last of which, not surprisingly, figures in the making as well as the appreciation of art. Each of these offers different adaptive advantages. Play and exploration are forms of mammalian behavior that prepare the young for adult life by providing opportunities for developing necessary skills and abilities. Communication, so important to humans, is essential for the formation and continuance of social groups. Finally, perceptual discrimination not only facilitates navigation of the natural environment but also, by means of pattern recognition such as recognition of faces and facial expressions, eases the way through the social milieu.

It follows from Alland's reasoning that art arose as a type of exploratory play, as a precursor to written language and as a satisfying and instructive perceptual stimulus. Although Alland acknowledges the contribution of culture to artistic creation, he emphasizes: 'The seductive aspect of art is biological in origin and is the essence of art' (1977, p.41).

Pfeiffer (1982, 1983), on the other hand, does not explicitly refer to the biological implications of early art. Based on exploration of pre-historic cave art, he has, however, provided an intriguing theory of why it suddenly flowered during the Upper Paleolithic or Stone Age. He considers cave art to have been part of a process of indoctrinating the young during a period when life was rapidly becoming more complicated. He has argued that in order to enhance memory, emotional stimulation was combined with information needed for survival and for successful group membership. Dramatic cave art, presented along with stirring, information-laden ceremonies, helped to accomplish this vitally important transfer of knowledge. Pfeiffer reconstructs this indoctrination process as follows:

> It involved three states: 1) leading the uninitiated through an eerie and difficult route, a kind of obstacle course to soften them up for indoctrination; 2) catching and holding their attention with shocking and frightening displays; and 3) finally, using every trick to imprint information intact and indelibly in memory. (Pfeiffer 1983, p.39)

Pfeiffer's ideas have apparently influenced Ellen Dissanayake (1992a, 1992b, 1995), who accepts his view but does not fail to make the evolutionary connection. Hers is a truly novel perspective; it is based on many years of scholarly research and observation that deserves to be considered in some depth. The remainder of this section will be devoted to doing just that.

Ellen Dissanayake's theories

In Dissanayake's view, the arts have been consistently undervalued in recent times. During the course of her investigations, she reviewed two dozen of the most noteworthy books on human behavior and evolution (deliberately excluding the works of Alland and Pfeiffer, mentioned above, because they expressly address art). As she suspected, many of the authors involved did not give art considered attention – some did not even

mention the word. Those who did discuss art making (about 50 percent) proposed origins or purposes that included 'play, display, exploration, amusement and pleasure, creativity and innovation, transformation, the joy of recognition and discovery, the satisfaction of a need for order and unity, the resolution of tension, the emotion of wonder, the urge to explain, and the instinct for workmanship' (1992b, p.10).

In spite of the relatively small number of contributors, this is a substantial list. Yet Dissanayake finds it unsatisfactory for a reason that those dedicated to art can appreciate: art is not *necessary* to the existence of anything on the list. It is Dissanayake's position that art *is* essential, that it involves a universal behavioral propensity of the human species that is part of our biological heritage.

To understand Dissanayake's species-centered (as opposed to culture-centered) theory, one must first appreciate her unique conceptualization of art – unique, that is, by contemporary Western standards. She points out that 'fine art', art made by and for an elite segment of society, is a relatively new phenomenon. Throughout the majority of human history, what we now call 'the arts' were not separate from daily life; anyone and everyone could participate in artistic behavior. Such behavior included singing, dancing, poetic storytelling, body painting and the decorating of possessions. The results of this type of art making were frequently ephemeral and certainly were not intended to be enshrined in a museum.

As civilization advanced, the arts became gradually more exclusive and exalted, culminating in the rarefied 'art for art's sake' of modernism. While the succeeding postmodernist movement has sought to dethrone art, it has not really returned it to the people. It has, Dissanayake proclaims, gone too far in abandoning previous esthetic standards for an absolute relativism that is itself esoteric. Dissanayake's definition of art, then, attempts to integrate the ways in which art has been approached over time. She states: 'The species-centered view of art combines modernism's proclamation that art is of supreme value and a source for heightened personal experience with postmodernism's insistence that it belongs to everyone and is potentially all around us' (1992a, p.173).

We are now ready to approach the cornerstone of Dissanayake's thesis. Art-oriented activities (along with play and ritual) are significant instances of a type of behavior Dissanayake designates 'making special'. She proposes that from an evolutionary standpoint, the urge to make special

arose from two distinct human propensities. The first is shared with other animals. It is a protective mechanism that involves the ability to detect anything that is out of the ordinary in the environment. The second is more exclusively human and involves the ability to select deliberate responses to needs or threats that go beyond the simple impulse to fight or flee. Dissanayake concludes that these propensities 'at some point resulted in deliberately *making* [important things] *special* – in themselves or in ceremonial rites' (1995, p.109). Her argument for the biological basis of art builds on this conjecture.

In summary, making special involves drawing attention to that which has significance for humans. Further, it is the essence of ritual observances. Throughout prehistory, rituals were instrumental in bonding participants and in passing on cultural values and information. They were also a way of allaying anxiety in response to life's uncertainties. As a result, individuals in societies that performed rituals survived better; that is, they had more children than those in societies without rituals and thus were favored by natural selection. The arts were (and are) intrinsic to rituals. Therefore, if rituals were crucial to survival, the arts were crucial to survival as well (Dissanayake 1992a).

Dissanayake presents a compelling case. Still, her explanation of the origins of art making contains some flaws. The most glaring of these is that a major criticism she directs at others – that their explanations are not exclusive to art – applies to her 'making special' hypothesis as well. In addition, it seems probable that a complex behavior like art making is more multidetermined than she indicates. However, the universal nature of art across times and cultures strongly supports her general conclusion that the need to make art is a direct result of biological evolution. Additional support is supplied by the evidence for innate esthetic preferences, by the pleasure that comes from art making (sensual pleasure being one of nature's ways of reinforcing biologically significant behavior) and by the benefits to be derived from still vital ritual ceremonies that we can witness today.

As regards the last, I was recently in a position to be such a witness and to observe some of the attendant benefits. While in the midst of writing this book, I took a short break to vacation in Italy with a group of other people. Our trip included a visit to the beautiful city of Siena, which retains much of its medieval heritage, including some centuries-old

customs. The timing was auspicious in that we were able to observe some of the festivities and pageantry that lead up to the *palio*, a bareback horse race held twice a year that dates back to the thirteenth century. The contenders in the race represent the 17 districts or *contrade* of the city. Each *contrada* has its own local officials, special community activities and an identifying emblem (for example, our hotel was in the district of the panther).

In the weeks preceding the big race, the youth of the districts take turns parading to the beat of drums, dressed in colorful medieval costumes and waving banners identifying their particular district. Other members of their district turn out to accompany them through the city's winding streets. Each district also has a celebration, a secular baptism of the children recently born into the district, that culminates in a street party with eating, games, singing and much laughter. (The one I looked in on even had a sort of graffiti mural activity in progress in which the younger children were participating.) All this was stirring to watch and was, we learned, only a small part of what was to come.

Although we were not able to stay in Siena long enough to experience the race itself, our local guide described for us the intense emotions and the chicanery that revolve around this climactic event. She told us that the *palio* can get quite rowdy and remarked that twice a year the citizens of Siena are 'allowed to misbehave'. She attributed the low incidence of drug addiction, delinquency and other types of destructive behavior among Sienese youth to the rituals and traditions of the *contrade*. Her words had the ring of psychological truth. They also supported Dissanayake's contention that participating in rituals promotes group cohesion.

But more substantive corroboration comes from another source. Sociologist Stewart Wolf conducted a decades-long investigation of life in Roseto, a small community in Pennsylvania. In *The Power of Clan* (1993), he and co-author John G. Bruhn reported that as the quality of social life declined in Roseto, so too did the overall health of its citizenry. It should be pointed out that Wolf was primarily interested in the medical significance of human relationships. Nonetheless, because he considered community life as a whole, his study is relevant.

Settled by Italian immigrants in the late 1800s, Roseto was for many years an exemplary place with an exceptionally low rate of heart attacks, minimal crime and delinquency, little unemployment and a high degree of

social cohesiveness. The latter was evinced by frequent participation on the part of residents in communal activities featuring social clubs, singing groups, church picnics, festivals and brass bands. During the 1960s, however, the gradual 'Americanization' of the town started to take its toll. The tightly woven fabric of community life began to disintegrate. Young folks moved away, the bands played less frequently, and the townspeople slowly became prey to the physical and societal ills they had previously avoided.

Roseto's shared social and artistic activities reflected, and undoubtedly enhanced, the tight bonds that connected its inhabitants. These bonds, in turn, promoted a style of life that was salubrious in a variety of ways. Although we cannot be certain which is chicken and which is egg, the notion that the community that celebrates together stays together is reinforced by Wolf's study.

Concluding remarks

Before moving on, Dissanayake's evolutionary perspective has several features that deserve further comment. First, she is not claiming that we possess some sort of 'art' gene, but rather that we have an inborn need to make special, and that this is readily expressed through art. Second, her view of art is a radical one (although perhaps less so for members of the arts therapies than for members of the Western art establishment). It is one that encompasses what is shared by all the arts and most crafts and stresses doing – or process – over product.

Finally, Dissanayake maintains that the cleavage between societal evolution and human evolution in regard to art is causing us trouble. As society became more complex, art became increasingly distant from mainstream culture. Our natures have not changed, however, and on a deep level we feel diminished by the removal of this form of making special from our daily lives. It follows then that, for the sake of our mental health, we must find ways to reintroduce art making into our everyday worlds.

The findings of neuroscience

Dissanayake's work focuses on the common threads that run through the various arts. But each art form has unique features. Some findings of neuroscience offer indications of the contributions that visual art in particular can make to our well-being. One of these is that visual art expression can facilitate language development. Another is that it can promote creativity and problem solving. A third is that it can stimulate feelings of pleasure and increased self-esteem that arise from our biological natures. A fourth is that it can represent an island of successful functioning in a sea of mental deficits. I will discuss each of these possibilities in turn.

I should add, as the reader is undoubtedly aware, that most of these contributions do generalize to all the arts. Although this is so, the following, except for a few instances, will deal with the specific neurological underpinnings of the visual arts.

Language acquisition

The evidence for a link between visual art and language development is exciting since it provides support for an intuited connection between the two. Over recent years, studies from brain science have accumulated, and together they make a convincing case: they reveal that graphic representation of images is a complex activity which involves a number of areas of the brain – some of which are intimately connected to language.

To begin with, art therapists may be surprised to learn that the brain's left hemisphere (where language function usually resides) is important for making art. Indeed, if this were not so, there would be scant basis for arguing that art is important for language development. It has been discovered that realistic rendering of a subject depends upon the left hemisphere for details and the right hemisphere for contour (Gardner 1982). This dependence on both hemispheres for well-realized images can be observed in the drawings of individuals with selective hemispheric damage. Those with right-hemisphere damage, who tend to neglect the left side of the page, produce well-detailed drawing fragments. Those with left-hemisphere lesions, on the other hand, produce complete contours of objects but include little or no elaboration. They frequently experience speech difficulties as well (Gardner 1982; Gilinsky 1984).

The investigations of neuropsychologist Doreen Kimura (1992) offer confirmation for these observations. Kimura reports that apraxia, difficulty in making appropriate hand movements, is strongly associated with aphasia, difficulty in producing speech, and that both of these deficits are a frequent consequence of left-hemisphere damage. She conjectures: 'The critical functions that depend on the left hemisphere may relate not to language per se but to organization of the complex oral and manual movements on which human communication systems depend' (p.124).

Perhaps more to the point, other researchers have found ties between language and specific movements involved in art making. Neuroscientist Chris Frith and artist John Law (1995) have collaborated to explore the brain mechanisms underlying the act of drawing. Using positron emission tomography (PET scans), they imaged the brain activity of volunteers who were 'drawing' forms in space. Their preliminary results suggest that drawing activates the region of the brain associated with identification of objects (which is language related) and the region of the brain associated with location of objects (which influences manual dexterity). They conclude 'that even the simplest drawing depends on a complex interaction between many brain systems' (p.205).

A recent British study reported by the New York Times News Service (Riding 1999) takes the research of Frith and Law a step further. As part of investigating the little explored processes of an artist at work, scientist John Tchalenko subjected portrait artist Humphrey Ocean to brain scans during the act of sketching faces from photographs. Results showed that the front part of Ocean's brain was more active than the rear where the visual cortex is located. This pattern of activity contrasted with that of non-artist controls who used mainly the back portion of their brains while undergoing the same procedure. Tchalenko summed up:

> For Humphrey, the real transformation was taking place in the front, where you find emotion, previous faces, painting experience, intentions and so on… In essence, the control subjects were simply trying to copy what they saw. But Humphrey was creating an abstracted representation of each photograph. He was *thinking* the portraits [emphasis added]. (Riding 1999, p.F7)

Although a newspaper article is not the equivalent of a scientific paper and must be interpreted with caution, the findings of this study are compatible

with other cited evidence. Thus it seems logical to surmise that as experience with art increases, the strength of the interactions between brain systems related to language and brain systems involved in drawing also increase.

The apparent close relationship, then, between thinking/language and fine motor coordination hints that improvements in one area might promote improvements in the other. Neurophysiologist William Calvin postulates that this is indeed the case. In *How Brains Think* (1996), Calvin notes that humans have a predilection for putting things together in structured sequences. He remarks: 'Besides words into sentences, we combine notes into melodies, steps into dances, and elaborate narratives into games with procedural rules' (p.95) – and art therapists might add: lines, shapes and colors into pictures. He proposes that such 'structured strings' reflect a core facility of the brain; that is, specific areas of the brain are involved in several kinds of sequencing and are more generalized in their functions than has been previously thought.

To support his thinking, Calvin cites the work of Kimura (already mentioned) and of neurosurgeon George Ojemann. As summarized by Calvin, Ojemann's findings, derived from electrically stimulating the brains of epilepsy patients, indicate that certain areas of the language cortex process sound sequences and also produce oral–facial movement sequences. It is this collective evidence of overlapping functions that leads Calvin to suggest that manual dexterity and language go hand in hand (so to speak).

Creativity, problem solving and self-esteem

Obviously, visual art requires more than thoughts and hand movements. It also relies heavily on vision – in all senses of the word. This is where its power to facilitate creativity comes in. Erich Harth's *The Creative Loop* (1993) provides an illuminating discussion of this topic. Harth, a physicist and researcher in the neurology of perception, has developed a neural model of visual perception. This model has led him to propose a mechanism by which mental images activate the same neural pathways as images from the external world. Harth's mechanism, supported by brain scan studies (Kosslyn and Koenig 1995), explains why we often respond to pictures in our heads as if they were things we actually see. But it does

more. It suggests a 'creative loop' that begins in the brain and can be extended into the environment. Harth states:

> We imitate reality, first only by producing mental images, pictures-in-the-head, nebulous structures that in their fleeting existence are able to spawn more images. When man learned to externalize images and place them alongside reality, he had taken a giant step. The great paleolithic cave paintings are mental images stored in pigment, thoughts frozen into stone so they can be recalled at will and reexamined. (Harth 1993, p.168)

In essence, he makes the point that when people learned to objectify their inner visions, the raw material for art and invention became available.

Education professor Robert Sylwester, drawing on studies in evolutionary psychology and the brain sciences (such as those presented in this book), extends similar thinking to all the arts. His article 'Art for the Brain's Sake' (1998) states the case for greater investment in arts education on the part of schools. He points out that there are 'windows of opportunity' for learning certain skills and cites research that backs this up. For example, playing the violin requires the use of both hands, each of which is controlled by separate brain areas. Violinists who start their studies before 12 years of age have been shown to have significant differences in these brain areas in comparison to those who do not play the violin – or, for that matter, to those who took up the violin later. (Although I am not aware of any studies that show an association between critical learning periods and the visual arts, we certainly have reasons for believing that earlier is better in terms of visual arts involvement. Some of these have already been presented – e.g. facilitation of language development – and there are more to come.)

Sylwester approaches the neurobiological evidence from yet another vantage point and finds a connection between art and self-esteem. Although it might seem obvious that artistic accomplishment bolsters self-esteem, Sylwester (1997, 1998) provides us with a biological understanding of why this should be so. He explains that fluctuations in the amounts of the neurotransmitter serotonin in the brain impact both the quality of movement and the level of self-esteem. High serotonin levels are associated with self-assurance and controlled movements while reduced levels result in irritability and impulsive behavior. Sylwester notes that human life depends on mobility and that, consequently, awareness of

effective and graceful movement produces feelings of satisfaction. He asserts that the arts provide training that can result in just this kind of skilled movement and that displays of such skill lead to positive feedback from peers, further enhancing self-esteem.

With good reason, then, Sylwester (1998) contends that early training in the arts, including arts appreciation, has the potential to develop young brains in an optimum manner. He proposes that maximized development will assist young people in meeting and creatively solving the problems of living in a complicated world.

Pleasure for biology's sake

We do not consciously elect to become involved with art in order to develop our brains, however. We do it at first simply because it gives us pleasure. Those exploring the workings of the brain offer some explanations for the pleasure we receive from the viewing and doing of visual art.

As mentioned earlier in this chapter, appreciation of art and other visual esthetic experiences may constitute a form of visual training. In an extensive note to *Phantoms in the Brain* (Ramachandran and Blakeslee 1998, pp.287–288), brain researcher V.S. Ramachandran asks if there is a universal grammar for visual esthetics and attempts to provide an answer. He observes that a rat trained to discriminate a rectangle from a square will give the strongest response to an exaggerated (elongated) version of the original rectangle. His explanation for this is that the rat learns a visual rule – 'rectangularity' – rather than a particular instance of that rule; and the easier the rule is to detect, the more it is intrinsically reinforcing. He maintains that the artist who portrays the essentials of an image and eliminates excessive detail (as most artists do) is assisting us in this process of rule detection.

Concerning the underlying brain mechanisms for this process, Ramachandran postulates:

> My hunch is that very early in evolution, many of the extrastriate visual areas that are specialized for extracting correlations and rules and binding features along different dimensions (form, motion, shading, color, etc.) are directly linked to limbic structures to produce a pleasant sensation, since this would enhance the animal's survival. Consequently, amplifying a specific rule and eliminating irrelevant

detail makes the picture look even more attractive. (Ramachandran and Blakeslee 1998, p.288)

The work of cognitive scientist Donald D. Hoffman provides at least partial substantiation for Ramachandran's conjectures. Hoffman's book *Visual Intelligence* (1998) details the operating rules of the visual system and presents examples from art history showing the discovery of visual rules by artists over the centuries. His work also hints at an explanation for the pleasure art gives us that goes beyond simple form recognition.

As the name of his book implies, Hoffman believes that vision should be considered among the most important functions of the human mind. Based on current thinking in neuroscience and psychology, along with his own explorations, he concludes that people possess three basic intelligences: visual, rational and emotional. As an aside, it should be noted that Hoffman's conception of several types of intelligence is similar to, yet different from, Howard Gardner's (1983) popular theory of multiple intelligences. Whereas Gardner is focused on a variety of intellectual competencies in which specific individuals might excel, Hoffman is interested in explaining the complex mental constructions that are necessary for visual perception in all sighted individuals. These mental constructions, Hoffman argues, are like language in that they are multi-staged, involving both innate (or universal) rules and specialized rules acquired through experiences in a particular culture. Additionally, he emphasizes the comparative importance of visual intelligence by pointing out that the brain systems responsible for vision occupy nearly half of the cerebral cortex. Likewise, neurologist Restak (1994) has noted that more brain neurons are devoted to vision than to any other of our senses. Neurobiologist Logothetis (1999), recognizing the significance of certain aspects of visual perception, has conducted studies employing visual stimuli in order to investigate the neural correlates of conscious activity.

Reflecting on Hoffman's thesis, we can reasonably conjecture that just as people enjoy exercising their rational intelligence in debates and their emotional intelligence by vicarious participation in dramas and stories, so too they enjoy exercising the complicated mechanisms of visual intelligence through the process of making art. Reflecting upon this and preceding conclusions, we can envision something similar to a vicious circle – but with a positive cast. This 'productive circle' consists of a mutually reinforcing cycle of pleasure in controlled movements that

produce exemplars of visual rules, which in turn result in heightened pleasure and increased self-esteem and, hence, smoother movements, etc. Furthermore, it seems apparent, once again, that it is the youthful artist (i.e. the individual in the earlier stages of development) who will have the most to gain from the attendant biological advantages.

Successful functioning

But the making of visual art is neither more nor less than its own reward for individuals of all ages with specific kinds of deficits. Over the years, people with developmental disabilities who display certain outstanding abilities have captured public attention. Among these so-called 'idiot savants' are some – like Nadia, the autistic child described by Lorna Selfe (1977) – who have exhibited extraordinary art skills. Now there is evidence that artistic ability can also accompany mental deterioration in a formerly well-functioning adult.

Neurologist Bruce L. Miller (1998) introduces us to John, who in middle age left his job at a brokerage firm and took up painting – although he had shown no previous interest in art. John explained to family and friends that he had a new ability to see vibrant colors that filled his head 'like notes of music' (p. 16). At first, no one was particularly impressed with John's artwork. Oddly, as his paintings became more striking and esthetically pleasing, his ability to comprehend language began to diminish, along with his ability to control his social behavior. Brain imaging revealed that he suffered from frontotemporal dementia, a degenerative disease that generally affects both the frontal lobes and the anterior portion of the temporal lobes of the brain. In John's case, however, only the temporal lobes were involved. Miller speculates that this unusual degenerative pattern left John's ability to plan and execute activities intact; at the same time, his visual imagery was heightened by loss of inhibitory circuits that turn off visual stimulation, 'perhaps allowing the artist in John to wake from dormancy' (p.19).

What is unusual about John and a small number of other patients that Miller has treated is the awakening of a creative impulse that is a forerunner of irreversible decline. Sadly, like the developmentally disabled with exceptional art skills, their involvement in artistic expression does not cure or lessen their disorder. For both groups, however, their creativity

provides an arena in which they can function effectively and surely adds to their quality of life. These cases alert us to the possibility that latent creativity can be activated in others with similar afflictions if we can but fan the spark. As a result of contact with his remarkable patients, Miller (Fink 1998) has stated: 'The big human message that I've learned is that dementia patients have strengths' (p.D11).

Artistic impulses can also be stimulated by traumatic brain injury (TBI). Physician Claudia Osborn (1998) has written a moving account of her adjustment to the consequences of a TBI. During the long process of rehabilitation, she took up painting – one of her few self-initiated activities. She reports that while her injury had numbed her responses to most stimuli, it had heightened her response to color. Further, painting along with writing became substitutes for her now impaired ability to speak:

> These acts of creating images pierced small holes in my sense of isolation. The joy I once had in spoken language, the release in confiding and sharing, the pleasure in intellectual exchanges with others, might now have two other expressions, however inchoate and primitive. If I could not speak what I felt, I would draw and write it. (Osborn 1998, p.127)

Unfortunately, the otherwise sophisticated rehabilitation program in which Dr Osborn participated did not seem to recognize the value of art therapy. Had it been included as part of the treatment, others who were less self-motivated might have derived similar pleasure in an enhanced sense of connection. It is important to note, though, that when providing therapy for those with cognitive deficits, the affected brain areas need to be taken into account. For example, Alzheimer's patients suffer extensive damage to the posterior of the brain. A consequence of this is that they lack visuoconstructive abilities (Miller 1998). Thus other creative therapies such as movement or music therapy – rather than visual art therapy – are the treatments of choice for these patients.

Research in psychology

Clinical psychology in the main has paid little attention to art and art therapy. The index of *A Guide to Treatments That Work* (Nathan and Gorman 1998), a compendium of therapies brought into being at the instigation of

the American Psychological Association, contains no mention of art therapy, expressive therapy or creative arts therapies. However, divisions of psychology other than clinical have light to shed on the benefits of the visual arts and the arts in general. Perceptual and cognitive psychologists and psychologists specializing in creativity have significant insights to offer.

Art as a cognitive process

The extensive writings of gestalt psychologist Rudolf Arnheim (e.g. 1969, 1974) and the work of cognitive psychologist Robert Solso (1994) attest to the cognitive nature of visual art. Arnheim states: 'Thinking calls for images, and images contain thought. Therefore, the visual arts are a homeground of visual thinking' (1969, p.254). Reversing the order, Solso makes a similar point: 'When we create or experience art, in a very real sense we have the clearest view of the mind' (p.xv). The inference to be drawn from these statements is that knowledge of cognition can help us understand art and understanding art can illuminate cognition. Although the focus here is on typical functioning, it follows logically that art can provide a means of determining if cognitive processes are functioning as they should in a given individual. Indeed, Rawley Silver (1989, 1996) is an art therapist who has built her career on this assumption and has conducted many studies that back it up. (I will have more to say about this and other types of art assessments in the following chapter.)

Art educator Paula Eubanks (1997) argues persuasively for the cognitive nature of art as well. Having surveyed research in psychology and in art, she concludes that art is a visual language that can aid schoolchildren in the development of verbal language. She recommends that 'art specialists' assist the classroom teacher in bringing this about. She states: 'Drawings provide a visual representation of the students' ideas onto which language can be mapped and an opportunity for students to request new vocabulary relevant to their interests.' She adds: 'Art can move from the fringes of the curriculum toward the core of learning for all young children, especially those for whom language acquisition is difficult' (p.34). Her investigations, coming as they do from a different perspective, strengthen the suggestions from neuroscience that art and language are connected. Of particular interest, her recommendation concerning art

specialists in the classroom points to a role for art therapists that has been underutilized – namely, working in the classroom with students at all levels of ability and functioning.

Obviously, the relationship between art and verbal language is far from simple. Psychologist Solso (1994) presents his conception of the correspondence between art and language – and underlines an important difference. He notes that language is conceived as having two levels: the medium (i.e. the letters on a page or the sounds of vocalization) and the 'deep structure' (i.e. the meaning conveyed by the medium). He suggests that art has corresponding levels, but adds a third level for art which he says is difficult to explicate. He describes this level as follows:

> It is being 'at one' with the art; it is commingling a painting with universal properties of the mind; it is seeing one's primal mind in a painting… It is a level of cognizance that arouses profound emotions and thoughts, and yet is itself inexplicable. It touches us. (Solso 1994, pp.256–257)

This sounds rather mystical, but Solso goes on to explain that the third level of art may be the result of activating a complex web of connections in the brain. These connections are the result of biology interacting with personal history and are largely outside awareness. We can speculate that what Solso is talking about is that something which gives visual art its power. (We can also speculate that he is referring in a general way to much which has been discussed in preceding sections in this chapter.) In addition, the ability to 'touch us' that he mentions suggests the potential of art to deepen any experience in which people relate through visual expression.

Art and optimal functioning

The psychology perspective encompasses a view of art that goes beyond honing cognitive skills – or even beyond apprehending Solso's mysterious and profound third level. Psychologist and creativity researcher Mihaly Csikszentmihalyi (1990, 1996) considers art making an enterprise that meets the conditions of what he calls 'flow' or optimal human experience.

Flow, as Csikszentmihalyi conceives it, is that which gives life joy and meaning. His formulation of flow derives from years of research in the

phenomenology of positive experience and has the following nine characteristics:

1. Clear goals.

2. Feedback regarding progress.

3. Exercise of skill.

4. Intense concentration.

5. Diminished awareness of mundane concerns.

6. A sense of control.

7. Loss of self-consciousness.

8. An altered sense of time.

9. Enjoyment of the experience for its own sake.

Anyone who has engaged in serious art making can confirm that these are indeed attributes of this particular undertaking.

Flow, however, is not limited to producing visual art. It comprises a range of activities such as sports, games, all the arts, ritual ceremonies and even more seemingly passive activities like reading. In all cases, though, there must be a degree of challenge present that is met by a commensurate amount of skill. As a result of successfully meeting the challenge, there is a feeling of accomplishment, a sense of psychological growth. It is this, Csikszentmihalyi maintains, that distinguishes the experience of flow from the experience of purely sensual pleasure. Such pleasure can occur without investment of skill or energy and thus fails to enrich us to the same extent as flow activities.

With Csikszentmihalyi's work there is a sense in which we seem to have come full circle. Despite different orientations and disciplines, psychologist Csikszentmihalyi and art historian Dissanayake appear to profess similar views. Both stress involvement in a process that is goal directed and requires special effort, and both regard the arts as important contributors to the well-being of our species. Csikszentmihalyi's 'flow' applies to a broader range of activities than Dissanayake's 'making special', and his focus is individual experience rather than evolutionary origins. Nevertheless, one is tempted to wonder if these two original thinkers are not describing the same animal from different vantage points. Indeed, Dissan-

ayake (1992b) has indicated that the experience of flow, in the sense of self-transcendence, is an ingredient of making special. In any case, what is worth emphasizing for the purposes of this book is the conviction shared by Csikszentmihalyi and Dissanayake that there is benefit to be had from creative endeavor which depends on exercising a certain amount of skill in a challenging or significant situation.

Addressing some negative evidence

Before getting carried away with the benefits that art making can bestow, however, some negative evidence must be addressed. The relationship between creativity and mental illness has long been a topic of interest and concern. Fortunately, recent research has brought some clarity to this topic. There is now considerable evidence indicating a connection between mood disorders, especially bipolar disorder, and high levels of artistic creativity (Andreasen 1996; Jamison 1993). There is even evidence of a connection between everyday creativity and milder mood swings such as are found in cyclothymia (Richards 1992). Does this mean that encouraging creativity can promote madness? The answer is a qualified no.

On the one hand, there does not seem to be any indication that exercising creativity causes bipolar illness – an affliction that we have strong reasons to believe has genetic roots (Barondes 1998; Jamison 1993). Indeed, Andreasen (1996) speculates that creativity and mental illness tend to co-occur as a result of hereditary personality traits that predispose an individual to both conditions. She remarks that possessing these traits can be 'a great gift and a great burden' (p.13).

On the other hand, there is a possibility that creative expression can exacerbate existing disorders. In his book *Creativity and Madness* (1990), psychiatrist Albert Rothenberg states:

> Pursuit of creative types of activity may be an intrinsic part of the mental illness of particular individuals...and may actually serve as an impediment to therapy. In such cases, a good treatment outcome could well include reducing or giving up artistic work. (Rothenberg 1990, p.169)

Likewise, art therapist Helen Landgarten (1990) takes a similar, but more art-friendly, view. Reflecting upon the torments of the famous Norwegian artist Edvard Munch (who apparently suffered from a mood disorder),

Landgarten points out how Munch's early artwork may have kept him in an unbalanced emotional state. She suggests that his many large expressionistic paintings depicting emotionally charged themes of love, death and despair served to increase (rather than alleviate) his distress. She indicates how she would have encouraged him to tone down his work had she been his therapist. In Landgarten's opinion, highly expressive self-involved art can become a form of rumination that tightens the grip of psychopathology.

Finally, art therapist Randy Vick (1998) recounts some anecdotal evidence that also challenges the notion that art making is inevitably curative. At a reception for the 'Migraine Masterpieces Competition', an art show sponsored by the National Headache Foundation for which he served as juror, Vick talked to a number of the winning artists about their art-making experiences. He was told by several of these artists that they did not find the act of creating art especially therapeutic and that at times it even precipitated headaches. Vick exhorts his art therapy colleagues: 'This observation…can serve as a challenge to us to work harder to understand what is clearly a more subtle relationship between creativity and health' (p.9).

Certainly, the suggestion that artists' creations can negatively influence their mental states does not seem unreasonable. Various aspects of the findings and conclusions presented in this chapter provide support. Obsessional thoughts and delusional ideas can be reinforced by making them special through artistic expression. Similarly, emotion-laden images can intensify unpleasant feelings through the tendency of our bodies to respond to all perceptions as if they originated from something real. Furthermore, those of us who are relatively intact artists know from our own experience that the process of art making can be intensely frustrating as well as ultimately rewarding. Think how much greater this sense of frustration must be for individuals with deficits in visuoconstructive regions of the brain. Obviously, the most health-promoting forms and circumstances of creative endeavor are yet to be fully determined.

Summing up

The foregoing review of scientific thought and research suggests that art, shortcomings aside, has significant benefits to offer. Conclusions supported by the evidence can be summarized as follows:

1. Participating in art and art-related activities satisfies something deep within us. This satisfaction can be attributed to the likelihood that the universal impulse to make art is either a direct or indirect result of our evolutionary history and thus is embedded in our genes.

2. Communal art making solidifies the interpersonal bonds that had survival value for our distant ancestors and that promote healthy living conditions for people today.

3. Art play, in which most children spontaneously engage if given the chance, promotes mind–brain development. Perceptual discrimination and language acquisition are facilitated and self-esteem is enhanced as a result. Implicit in this conclusion is another: *all* children should be provided with ample opportunity for art making throughout their growing-up years.

4. In addition to offering developmental benefits, exercising visual intelligence through the appreciation and creation of art evokes sensual pleasure and thus provides a source of constructive gratification that can magnify the sense of satisfaction mentioned above. (The potential for substituting this form of gratification for more destructive forms could be construed as a type of sublimation – minus Freud's metapsychological rhetoric.)

5. Visual art expression facilitates problem solving and other forms of creativity. By externalizing our inner visions, we are able to modify, refine, extend and apply them in a variety of situations. In sum, art assists us in usefully organizing our thoughts and experiences.

6. Creating visual art provides one of the few opportunities for successful functioning for those with certain cognitive impairments. The impulse to make art is even stimulated by some types of brain damage and, under these circumstances, can be viewed as a strength that arises out of weakness and in some degree compensates for what is lost.

7. The visual thinking involved in art making indicates that art offers a non-verbal approach to assessing cognitive development

and deficits. It also means that art can provide an alternate form of communication for the language impaired.

8. Art has the potential to deepen the therapy experience. This stems from its ability to touch us on deep levels and from 'making special' the context in which art making occurs.

9. Art is among those activities that can improve the quality of life for all who undertake them. When art making partakes of the characteristics of 'flow', it provides the kind of optimal experience that produces feelings of psychological growth and makes life in general more worth living.

These nine benefits of art and art making can be divided into two general categories: art as life enhancement and art as rehabilitation. Both types of benefits can be usefully applied in therapy (more about this in the final chapter). Most important, these benefits make it abundantly clear that the therapeutic value of art is by no means limited to the expression of unconscious wishes, conflicts and emotions. Although there are some drawbacks to engaging in artistic creation (the very little humans do is an unqualified good), the balance is decidedly tipped toward the positive side of the scale.

Interpretation of Artwork

A Reassessment

Interpretation of drawings and other works of art has three major functions or purposes. First, there are the projective and the neuropsychological drawing tests that are part of the clinical psychologist's tool kit for assessing personality and arriving at differential diagnoses. Second, there are the art assessment procedures that the art therapist uses in order to develop art therapy treatment plans. (This can, and often does, include one or more drawing tests developed by psychologists.) Third, there are the generally collaborative efforts of client and therapist in art therapy treatment to decode the client's personally meaningful artistic symbols. In what follows, all of these functions of interpretation will be re-examined in the light of current research.

Projective drawing tests

Aside from those who have developed and use them, projective drawing techniques are not held in high esteem by psychologists as a whole. For example, Stuart Vyse (1997) makes the strong statement that the Draw-A-Person (DAP) test has no validity (p.117). His evaluation may seem, and indeed probably is, an overstatement. It is, however, backed up by studies like that conducted by Z. W. Wanderer (1969/1997), in which a panel of experts was unable to correctly identify members of criterion groups based on their DAP drawings. The five criterion groups comprised representatives of retarded, schizophrenic, neurotic, homosexual and normal populations. With the exception of the renderings of the retarded, a panel of 20 DAP experts, including people of some renown such as Emanuel Hammer and Karen Machover, could not distinguish between the drawings of the different groups at a better than chance level.

The cumulative results of many additional studies of the DAP and other projective drawing techniques are somewhat more encouraging – but only for certain types of interpretative schemes. Having surveyed the literature, David Smith and Frank Dumont (1995) summarize the findings of four decades of research as follows:

> Of the various relationships between drawings and diagnostic criteria that have been researched, only the relationship between global measures (i.e., rating schemes that consider the drawing as a whole or a set of specific features in the drawing) and diagnoses of gross maladjustment has reached levels of statistical significance with some consistency… The research has also clearly shown that specific signs in human figure drawings, including structural (e.g., placement of drawing on page, shading, erasures, etc.) and content variables (e.g., the rendering of a specific body part), are invalid indicators of personality or pathology. (Smith and Dumont 1995, p.299)

Gary Groth-Marnat, whose *Handbook of Psychological Assessment* (1997) provides a balanced critique of the assets and limitations of projective drawings, essentially concurs with Smith and Dumont. He points out, however, that certain types of drawing ratings can serve with some success as non-verbal measures of children's cognitive ability. These methods of drawing analysis – of which Harris's (1963) revision of the Goodenough Draw-A-Man Test is a good example – employ quantitative scoring of formal features, such as number of details, rather than impressionistic schemes that assume isomorphy between drawing signs and personality characteristics.

Given the evidence, it appears that quantitative ratings of selected drawing features are the key to developing drawing tests with at least modest claims to validity. As a case in point, Waldman *et al.* (1994) were able to detect significant differences between incest survivors and a control group by using the Draw-A-Person Questionnaire (DAPQ). This is a procedure developed by one of the authors (Karp 1990) that involves producing the usual DAP drawings of a male and female figure. Partici-pants are then asked to fill out questionnaires about the drawn figures as though they were real people. The major portion of each questionnaire consists of five-point scales on which these imaginary characters are rated for attributes such as happiness, helplessness, and so on. This innovative technique combines projective and objective components while avoiding

some of the confounding factors that plague the more traditional drawing tests.

Make no mistake, there is strong evidence that drawing tests are vulnerable to a number of extraneous variables. Interestingly, one of those who has advanced the use of projective drawings has made a contribution in this area. In her book *Psychological Evaluation of Human Figure Drawings by Middle School Pupils* (1984), Elizabeth M. Koppitz takes note of the foremost of these potentially confounding factors: variations in drawing ability and differences in cultural background. Concerning drawing skill, she observes:

> When evaluating the drawings of young adolescents, it is common to overestimate the mental ability of artistically gifted students and of those with good visual–motor skills, and to underestimate the ability of those with poor visual–motor ability. (Koppitz 1984, p.93)

Although she presents no research that confirms this observation, the contaminating influence of artistic skill receives support from a substantial number of empirical studies (Cressen 1975; Sherman 1958; Whitmyre 1953).

In regard to culture, on the other hand, Koppitz reviews several cross-cultural studies carried out by herself and others that demonstrate the sensitivity of human figure drawings to cultural influences. She indicates that this sensitivity can be used to track group changes in social and cultural values. Unfortunately, she neglects to mention the misinterpretations that can arise when attempting to extract psychological information from drawings by members of other cultures. This is not a mistake made by Claire Golomb (1992), however. She cites studies that suggest such misinterpretations are indeed likely. Further, having studied children's art extensively, Golomb subscribes to a theory of innate predispositions that result in more or less universal stages of pictorial representation. Yet, at the same time, she acknowledges that the impact of cultural and individual differences on children's art is significant.

Faced with the preponderance of negative evidence, one might wonder why clinical psychologists continue to use drawings for personality assessment. The researchers Chapman and Chapman (1971) have suggested that 'illusory correlation' is responsible. As defined by them, illusory correlation is 'the tendency to see two things as occurring

together more often than they actually do' (p.20). Through a series of cleverly designed experiments, Chapman and Chapman have shown this phenomenon in action. In an initial study, college students unfamiliar with the DAP were given drawings of male figures with descriptive statements about the problems of the men who presumably drew them. They were asked to examine the drawings for features common to men with the same problems. Although there were no relationships between the drawings and the problems attached to them, relationships were perceived by almost every student. Furthermore, the relationships that the students saw (e.g. emphasized eyes correlate with suspiciousness) were similar to those that experienced clinicians reported finding in diagnostic drawing tests.

Subsequent experiments by Chapman and Chapman (1971) have revealed how hard it is to overcome an illusory correlation. In one study, problem statements were deliberately placed on drawings containing the opposite of the expected drawing feature. For example, the problem 'worried about intelligence' was consistently paired with pictures with small heads, and a statement about suspiciousness was placed only on drawings with small eyes. Remarkably, even though it was somewhat diminished, evidence of illusory correlation remained.

The implication of the Chapmans' work – that not only untrained students but experienced psychodiagnosticians tend to see what they expect – has received confirmation from a more recent study by David Smith and Frank Dumont (1995). Most disturbingly, the cumulative evidence suggests that clinicians' expectations are based more on pop psychology than on training or experience. Wanderer (1969/1997) offers an alternate explanation for the ongoing popularity of projective drawings. He speculates: 'Could the occasional, eloquent drawing provide the clinician with partial reinforcement, producing greater resistance to extinction?' (p.313). This is a question I am personally, and ruefully, tempted to answer in the affirmative since for years I have used in my teaching just such an eloquent – and exceptional – drawing. But whatever the case, and both explanations could be in operation, projective drawings have failed to establish themselves as sufficiently valid from a scientific perspective.

Nonetheless, this does not mean that we must totally exclude art from the armamentarium of the diagnostician. Groth-Marnat (1997) notes:

Some authors have...suggested that drawing techniques be con-
sidered not so much a formal test but rather a way to increase
understanding of the client based on client/clinician interaction
related to the drawing, or to help access important life experiences.
(Groth-Marnat 1997, p.504)

Neuropsychological drawing tests

Drawing tests of visuoconstructive abilities indicative of brain damage
have a better reputation with psychologists than projective drawing tests.
Results of reliability and validity studies for the former are considerably
better than for the latter (Groth-Marnat 1997). Among the drawing tests
used to assess brain dysfunction are the Bender Gestalt, human figure
drawings, and drawings of single objects such as a clock, Greek cross or
bicycle.

The Bender Gestalt (Bender 1938; Lacks 1984) is probably the most
popular and most respected of these screening devices. It consists of nine
relatively simple designs that are copied by the client and then scored for
accuracy of reproduction and for behavior while drawing. It has been used
to assess level of maturation in children as well as to assess brain
impairment in adults. Attempts have also been made to use the Bender as a
projective test, but like other projective drawing tests, it has not been
particularly successful in this arena (Groth-Marnat 1997).

Although the Bender has a good record of detecting brain damage, it
has its limitations. False negatives occur because not all types of brain
dysfunction affect representational abilities – it depends upon where the
brain lesions or deficits are located. Further, the Bender is often unable to
discriminate 'functional' psychosis from 'organic' impairment (Groth-Marnat
1997; Lacks 1984). The difficulty here, however, may be due more to our
way of classifying psychiatric disorders than to a problem with the test.
Increasingly, we are realizing that all psychiatric disorders are, in a sense,
physical disorders. The most recent edition of the *Diagnostic and Statistical
Manual of Mental Disorders (DSM-IV)* (American Psychiatric Association
1994) states (somewhat apologetically):

Although this volume is titled the *Diagnostic and Statistical Manual of
Mental Disorders*, the term *mental disorder* unfortunately implies a
distinction between 'mental' disorders and 'physical' disorders that is a

reductionistic anachronism of mind/body dualism. A compelling literature documents that there is much 'physical' in 'mental' disorders and much 'mental' in 'physical' disorders. The problem raised by the term 'mental' disorders has been much clearer than its solution, and, unfortunately, the term persists in the title of DSM-IV because we have not found an appropriate substitute. (APA 1994, p.xxi)

What we might expect, then, from a test like the Bender is an ability to differentiate between brain disorders that are usually amenable to repair or improvement and those that are not. Except in the case of schizophrenia, the Bender seems able to do this to a reasonable degree.

Still, the Bender makes only gross diagnostic discriminations – a criticism that has also been made about the best rating schemes for projective drawing tests (Smith and Dumont 1995). Thus, accurate and consistent differential diagnoses based on a single drawing or even a set of drawings do not seem possible. Indeed, Groth-Marnat (1997), in his comprehensive review of psychological assessments of all types, makes it clear that a battery of different tests is generally necessary for such purposes.

Art therapy assessments

Development and validation of art-based assessments is one area where art therapists have some significant research to contribute. Adding these findings to those from psychology will put us in a better position to evaluate current approaches to the interpretation of artwork and enable us to have a more realistic idea of what client art can and cannot tell us.

Both form and content are considered when art therapists analyze art. However, evidence from art therapy research provides indications that form offers more solid information. These indications come from several sources. An early study by Elinor Ulman and Bernard Levy (1975) investigated the ability of people to detect psychopathology in paintings. Eighty-four judges, 56 of whom were mental health workers, assigned 96 paintings to either a patient or a non-patient category. Most of the judges were able to discriminate between the paintings to a statistically significant degree. Surprisingly, those with mental health training – including the art therapists among them – performed no better at assigning drawings than those without training. (This is a humbling finding and

suggests a need to revise the assumption that art therapists are the only ones who can successfully 'read' art.)

After carefully scrutinizing the accurately assigned paintings, Ulman and Levy arrived at the following conclusion:

> In the past we have been much concerned with *content* and its symbolic implications. Our present study suggests that research centered on *form* and its correlation with personal characteristics may point the way toward greater reliability in the use of paintings for diagnostic purposes. (Ulman and Levy 1975, p.402)

Building on the work of Ulman and Levy, Linda Gantt and co-researcher Carmello Tabone (1998) have developed an art assessment and research instrument that yields diagnostic information by evaluating global characteristics of form. Using a scale originally devised by Gantt (1993) called the Formal Elements Art Therapy Scale (FEATS) and employing the directive 'draw a person picking an apple from a tree', Gantt and Tabone have conducted studies indicating that a single drawing can detect certain mental disorders. In developing the FEATS, they have focused on four diagnostic categories: major depression; bipolar disorder, manic phase; schizophrenia; and organic mental disorders. They have found, for example, that 10 of the 14 subscales of the FEATS discriminate between two or more of these major clinical syndromes to a statistically significant degree. Their research also suggests that as psychiatric illness abates, patient drawings tend to normalize. Indeed, they have found measurable differences in drawings collected over the course of treatment, offering the possibility of using the FEATS as part of an assessment battery that tracks improvement (Gantt, personal communication, 26 June 1999). This is an exciting prospect since self-report inventories and hospital staff observations often give a limited or inaccurate picture of patient progress.

Based on her investigations, Gantt concludes that we need to 're-examine the assumption underlying virtually all projective drawings – that the constituent parts somehow reflect personality traits' (Williams *et al.* 1996, p.20). With these words, she echoes the concerns of the research psychologists cited above.

Other art therapists have had success in devising form-based assessments as well. The most notable of these assessments are the Silver Drawing Test of Cognition and Emotion (SDT) (Silver 1996) and the

Diagnostic Drawing Series (DDS) (Cohen, Hammer and Singer 1988; Cohen, Mills and Kijak 1994). The SDT was first introduced by pioneer art therapist Rawley Silver in 1983 and continues to be refined. It was designed to assess the cognitive development of those with language deficits and consists of three subtests: Predictive Drawing, Drawing from Observation and Drawing from Imagination. The last of these subtests is scored for emotional content as well as for cognitive functioning. The reliability and validity studies for the SDT have been largely positive. Although the scoring for Drawing from Imagination is derived partially from content, it involves global evaluations of themes rather than impressionistic interpretations of specific details.

The DDS initiated by Barry Cohen and colleagues is an ambitious undertaking with the goal of establishing objective graphic profiles for different diagnostic groups. Many art therapists have collaborated (and continue to collaborate) in amassing data to develop this three-picture assessment which involves doing a free drawing, a tree drawing and a feelings drawing. As in the case of the FEATS, the results of DDS research are indicating that relationships exist between structural elements of artwork and psychiatric diagnoses.

As a final example of structural analysis, the examination of drawings to determine developmental level should be mentioned. This generally impressionistic analysis practiced by art therapists is based on the stages of drawing development observed in the art of normal children and assumes that arrested development in art equals arrested development in general. Frances E. Anderson (1992) provides an excellent overview of normal children's artistic development and also points out some difficulties with applying this yardstick. As psychologists have noted, a paramount problem is the impact of culture on children's art. Whereas there seems to be reasonable universality of stages for preschoolers, Anderson cites studies that show culture wields an increasing influence on the art of older children. For example, some cultures may discourage graphic representations while others may strive to promote accelerated graphic development. Given these circumstances, one should use caution in assuming developmental level is reflected in art when dealing with either school-aged children or adults. It is also unlikely that the other form-based assessments reviewed above are entirely culture-free.

In spite of their apparent promise, two additional caveats must be tendered concerning form-based assessments designed by art therapists. First, little effort has been made to control for artistic training and ability. Some years ago, I took initial steps to develop a drawing rating scheme for ego development (Kaplan 1991). I obtained a weak correlation between my ratings of formal drawing elements and a verbal measure of ego development. This correlation was enhanced, however, by removing from the sample those with minimal art experience. To my surprise, the influence of drawing skill on my rating scheme turned out to be my most compelling result. (Again, as mentioned earlier in this chapter, psychologists have recognized this confounding variable.)

Second, individual variation coupled with the nature of the particular disorder dilutes the clinical (as opposed to the research) utility of art assessments. That is, relationships between pictorial elements and symptoms or deficits can be statistically significant while accounting for substantially less than 100 percent of afflicted individuals. This is frequently, nay usually, the case. In the study by Ulman and Levy (1975), 44 percent of the paintings by normals and 81 percent of paintings by patients were judged correctly. Since clinicians deal with individuals, even a 20 percent error rate is significant. Further, it should be kept in mind that Ulman and Levy made no attempt to assign patients to diagnostic categories. A simplistic distinction between patient and non-patient offers little clinical benefit, while attempting specific diagnoses based on drawings introduces more complex variables that tend to reduce the success rate.

Although the FEATS and the DDS have made progress in assigning diagnostic categories, it is unlikely that these assessments – or any other art assessments – will ever evolve into all-purpose diagnostic instruments. The fact is that, as noted in discussing the Bender Gestalt test, how a person draws reflects some, but not all, types of dysfunction. It is heartening, though, that art therapists have chosen to engage in the arduous task of developing valid rating scales for structural elements. As studies with these instruments progress, members of the field of art therapy will be better able to apprehend the ways in which the visuoconstructive abilities of the brain are affected by a range of mental disorders.

The (at least partial) success of the analysis of form in artwork contrasts with the general failure of content as a reliable source of information.

Studies by psychologists of the validity of qualitative interpretations of drawings have been particularly discouraging. Looking at the art therapy evidence concerning a few of the assumptions underlying such interpretations does little to upgrade their status for assessment purposes. For instance, Vija Lusebrink (1990) has detailed the emergence of symbolism within the context of cognitive development and, in the process, has described the rudimentary nature of early mental imagery. Further, some research of my own (Kaplan 1998) has suggested that the content of certain types of imagery is largely a consequence of age and level of sophistication. Thus the related assumptions – that drawings can reveal meaningful preverbal imagery and that images remain consistent over time – seem dubious at best.

As another example, Anita Rankin (1994) has reviewed psychology research in relation to the validity of trauma indicators in tree drawings along with conducting a related study of her own. The assumption under investigation in this case was that the tree is a representation of the artist over time. Rankin takes the position that this is not necessarily so. She points out that the tree may represent the artist at a particular point in time, a person other than the artist, or even just a tree. Although she found some support for a relationship between multiple signs of injury (scars, broken branches, absence of leaves) and past trauma, she found little support for the popular idea that one or two knot-holes signify a traumatic event. Nor did she find support for the notion that the date of a traumatic event can be calculated from the position of a scar on the trunk of the tree.

Following Rankin's lead, more art therapists need to investigate commonly held interpretative assumptions by reviewing the research literature and conducting companion studies. When art therapists base their assessment findings on an unquestioned acceptance of the 'received wisdom', they very much run the risk of barking up the wrong tree!

About symbolism

However, assessment is not all there is to art therapy. A brief consideration of symbolism and its overall place in art and art therapy is in order. Dissanayake (1992b) maintains that 'just as all symbols are not art, neither is all art symbolic' (p.91). She points out that the design aspect of art is gratifying in itself and that representational meaning may be secondary or

absent. Arnheim (1974), on the other hand, appears to disagree. He makes a case that form and subject matter cannot be separated and states that 'even the simplest line expresses visible meaning and is therefore symbolic' (p.461). He goes on to say, however, that abstract art does not provide intellectual abstractions, constituted as it is of concrete elements – color, shape and motion. Thus the difference of opinion between these two theoreticians seems to be more a matter of semantics than substance.

Certainly, it is quite possible for a person to derive therapeutic benefit from creating art that has little symbolic content. For example, a participant in an inpatient psychiatric art therapy group spontaneously produced a colorful and striking design in response to being asked to do a drawing in a circle. The other members of the group were impressed with the beauty of the design and said so. The creator, a man who tended to be excessively perfectionistic, was delighted. He remarked that this was the first time he had ever accomplished something without pre-planning it to death. No attempt was made to hunt for and decipher 'symbolism' in the drawing; the meaning was in the process, not the product (Figure 6.1).

Figure 6.1 Spontaneous drawing in a circle by perfectionistic client

Figure 6.2 Drawing by recovering addict depicting consequences of drug addiction

Nevertheless, art can (and often does) contain subject matter that signifies more than the obvious. When this type of art is produced in art therapy, therapist and client can obtain important information by exploring the deeper meanings. The scientific evidence suggests, however, that artistic symbolism often comes from conscious (as opposed to unconscious) sources. Referring to a finding from the considerable body of psychology research on human figure drawings, Sophia Kahill (1984) remarks: '[This] suggests that in contrast to the hypothesis that drawing tests are revealing undisclosed aspects of personality, subjects may be aware to some extent of what the drawings reveal' (p.273). Further, as we have seen, current brain research offers little support for the existence of an unconscious 'planner' striving to express itself in cleverly disguised form.

Of course, there are those occasions when the art therapy participant deliberately employs visual metaphor. A recovering addict produced a scene of destruction and devastation with herself as a solitary figure sitting among the ruins. She said that she had drawn this striking image to remind

herself of what her world would be like if she continued to use heroin. No further interpretation was wanted or necessary (Figure 6.2).

I do not mean to say that imagery portrayed in art cannot arise from associations or stimuli that occur either outside conscious awareness or so quickly that they are unable to be stored in memory and thus cannot be recalled. But any meaning attributed to this kind of imagery is generally applied after the fact. Although the result may have significance for the artist, it is more likely to be a construction than a reconstruction and should be recognized as such. We are reasoning creatures; if a logical explanation for something is not immediately apparent, we will often manufacture one. Gazzaniga (1992), in his experimental work with 'split-brain' patients, has frequently observed this process in action.

Split-brain patients have had the connection between the left and right hemispheres of the brain severed for medical reasons. Studies of these patients have revealed that the left hemisphere is organized for high-level consciousness. They have also revealed that while the right hemisphere has many of the same information processing systems as the left, it is not organized for conscious thought. Thus a stimulus presented to the right hemisphere of a split-brain patient will evoke a response for which the left hemisphere, unable to access the real reason, offers a plausible but inaccurate interpretation.

In the following example, Gazzaniga relates the result of a simultaneous concept test. This test involves showing two pictures to a split-brain patient, one to the visual field of each hemisphere. The patient is then asked to pick from a selection of pictures the images most closely associated with the test images (keep in mind that the right hemisphere of the brain controls the left side of the body and vice versa).

> A picture of a chicken claw was flashed to the left hemisphere, and a picture of a snow scene to the right hemisphere. Of the array of pictures placed in front of the subject, the obviously correct association is a chicken for the chicken claw and a shovel for the snow scene. [The patient] responded by choosing the shovel with the left hand and the chicken with right: That is, the right hemisphere matched the snow scene. When asked why he chose these items, his left hemisphere replied, 'Oh, that's simple. The chicken claw goes with the chicken, and you need a shovel to clean out the chicken shed.' (Gazzaniga 1992, p.124)

Another experimental demonstration of the phenomenon of left-brain interpretation involves flashing a word such as 'walk' to the right hemisphere. In most cases the right hemisphere of the brain can respond to simple written commands. When patients respond to these commands, they are asked for an explanation. Upon getting up to walk away from the testing area, for instance, a patient might answer, 'I'm going to get a drink.' Gazzaniga and his co-workers have conducted numerous studies of this nature yielding similar results. The wisdom to be garnered by art therapists from these findings is that interpreting spontaneous art images motivates the artist to offer explanations that are rationalizations and should not be regarded as messages direct from the unconscious.

Conclusions

We are now in a position to draw a few inferences about the interpretation of artwork in assessment and in treatment. I believe the following conclusions are justified:

1. The paucity of research support for sign-based interpretations suggests that traditional qualitative interpretive manuals for projective drawing techniques (e.g. Jolles 1971; Machover 1949) should be discarded or used very selectively. In this regard, Groth-Marnat (1997) provides a good review of the standard interpretations that have received some support. (Interestingly, most of these relate to form rather than content.) Further, this conclusion is strengthened by another consideration. The hypothesis that underlies the DAP and similar drawing techniques – that unconscious conflicts, feelings and ideas are projected into the artwork – requires acceptance of the Freudian concept of the unconscious. As discussed in Chapter 4, recent findings in psychology and elsewhere have called this understanding of the unconscious into question.

2. Formal aspects of art have the greater claim to universality and thus offer the best basis for constructing meaningful rating scales for art. In devising and refining such instruments, however, the confounding factors of art skill and cultural background, the impact of individual variation within populations and the nature of the mind–brain disorder should be taken into account. At this

point, most existing instruments are of limited clinical utility. They can make gross discriminations between art done by those suffering from severe mental disorders but generally cannot make finer distinctions. In addition, it is highly unlikely that art tasks used alone will ever be able to pinpoint all problem areas. Nonetheless, it is important that art therapists understand the full extent and limitations of what art can reveal. It is a decided service to the profession that a number of art therapists are seriously engaged in research directed toward this goal.

3. There is a degree of universality to the stages of pictorial representation that children typically go through, but this decreases as children age. Thus, assessments of cognitive development based on stages of artistic development are most valid for young children. For teenagers, and by extension adults, what can seem like arrested or accelerated development from this perspective may reflect either cultural influences or the particular representational stage at which the person gave up doing art – or both.

4. Even with today's sophisticated brain scan technology, drawings can be an easy and inexpensive way of screening for brain dysfunction. It should be kept in mind, however, that overall brain impairment or impairment localized in the visual/spatial areas of the brain are the types of dysfunction most readily detected in this manner.

5. When it comes to the interpretation of subject matter in assessment or in treatment, it should be kept in mind that the meaning or value of a piece of art is not necessarily symbolic in any significant sense. Further, much meaningful symbolism is consciously determined; thus it is truly the artist who holds the key to its meaning – although the therapist can sometimes make an educated guess based on comprehensive knowledge of the client. In the case where art results from spontaneously arising imagery, interpretations should be made with caution. Clients' comments about their imagery can be revealing in terms of thinking patterns and preoccupations. Their reflections may also assist them in gaining new perspectives on problem behaviors.

But neither the client nor the therapist should view the art as an incontrovertible source of information about traumas or conflicts hitherto unknown.

6. Art assessments have more to offer than grist for the interpretive mill. As has been noted, artwork can provide a catalyst for client–therapist interaction. In addition, there are two important aspects of the art therapy assessment process that have not been mentioned. First, along with gathering other information, the art therapist uses assessments to observe clients' reactions to art materials. This part of the process includes noting responses to a variety of media, discovering the ways in which the client goes about completing art tasks and determining overall suitability for art therapy treatment. Such information is readily observable by the trained eye, does not require esoteric means of evaluation and is invaluable for formulating an art therapy treatment plan. Judith Rubin's (1984b) *Child Art Therapy* provides a lucid discussion of this art-focused feature of art therapy assessment.

Second, art assessments can provide useful data about client strengths. Here is where content (evidence of metaphorical thinking, qualities ascribed to self, etc.) can make a meaningful contribution. Most important, here, too, is where ability to be creative through art can reveal itself as a significant asset.

The above conclusions, together with those at the end of the preceding chapter, are suggestive of where the emphasis belongs in the practice of art therapy. Art therapists have frequently chafed at the notion, held by many outside the field, that their primary job is analyzing artwork. Given the evidence (or lack thereof), this is certainly not where the emphasis belongs. Art assessment is, of course, an important preliminary to treatment. But involving clients in the doing of art – with or without discussion of the product – is undoubtedly the major contribution that those who use art for health's sake have to make.

7

Toward a Scientific
Art-Based Theory

Knowledge about how the brain works tells us that connections and associations are happening outside our conscious awareness (or outside our memory of awareness) all the time and are influencing our behavior and emotions. Many of these associations are less than profound; they only seem so because we do not know what evoked them. Many of them lead to false conclusions, again for the same reason. Sometimes we are able to effect a reasonable reconstruction of unconscious mental events and thereby intervene in a process that might otherwise have unwanted consequences. Sometimes art can assist in illuminating and demythologizing this process. Sometimes – because it stimulates additional associations at all levels – art can obfuscate what originally occurred. At the same time, due to these associations, it can lead to new perspectives. Art, it seems, is less about uncovering than discovering.

If unconscious mentation is not as we have thought, what is the true nature of art's relationship to the unconscious and what are the implications for art therapy? Although some tentative answers have been offered in preceding chapters, they remain to be incorporated in a unified theory of art therapy. Likewise, other facts and ideas presented in these pages await evaluation and integration. The purpose of this final chapter is to clarify the task ahead in the interests of beginning the integrative process.

The scope of the undertaking

A scientific theory of art therapy must take into account the findings of evolutionary biology and anthropology concerning humankind, the findings of neuroscience and psychology concerning the workings of the human brain and the findings of the physical sciences concerning the laws of nature. It must also take into account what research in these and other disciplines has to say or suggest about the benefits of art making, the limitations of art interpretation and the possible negative effects of certain uses of art and imagery. It must reconsider the relationships between art therapy and verbal psychotherapy and between art therapy and the work of the artist. And it must address several issues that await research within the field of art therapy itself.

There are two main areas where only art therapy research is likely to supply us with substantive information. One has to do with the 'What works for whom?' of art therapy treatment. The answer to this question requires more than simple outcome studies. Most reasonable therapies show positive outcomes when clients are compared to no-treatment controls. These positive results are, at least in part, due to non-specific placebo effects. Although art therapy may hold a special relationship to the placebo effect, as psychiatrist Louis Tinnin (1994) has suggested, studies that yield more detailed information are very much needed.

Tinnin's ideas are sufficiently interesting, however, that it is worth digressing a moment to consider them. He has postulated that the placebo effect can be enhanced by a specific art therapy technique. The placebo effect, he maintains, is one of several types of responses that originate in a preverbal mimicry mechanism located in the most primitive part of the human brain. This mechanism plays an important part in how babies learn, and continues to operate throughout life. It is involved in such aspects of mature functioning as non-verbal communication, empathy and emotion. Thus, Tinnin hypothesizes, an art therapy approach that provides both a healer (therapist) and healing images (artwork that depicts the eradication of troubling symptoms) has the potential to compound the placebo effect through increased opportunities for unconscious mimicry.

But even if Tinnin's hypothesis should prove to be the case (and it should certainly be tested), experimental studies that compare the efficacy of different art therapy treatments and exploratory studies that investigate the experience of art therapy for recipients are required to advance the

field. An example of the former is a quantitative study by Carol L. Miller (1993) that compares a standard approach to art therapy with an art history-enriched approach which she developed. (The results indicated that the art history-enriched approach decreased anxiety and increased time on task for chronic psychiatric patients.) An example of the latter is Susan Spaniol's (1998) ethnographic investigation of the attitudes toward art therapy of those with psychiatric disabilities. (Interestingly, Spaniol found that her informants valued the creative product over the process.) More will be said in regard to these studies below. It is lamentable, however, that only a few such studies exist at the current time.

The second area that requires art therapy research is related to the first. It involves determining the appropriate art media for particular treatment situations. Without conducting any studies, it is obvious that some media are harder to control than others and that this has treatment implications. Thus the use of finger paints would not be advisable in an initial session with an individual known to have poor impulse control. But some other ideas about the use of media are questionable. For instance, prevalent notions are that clay and paint are regressive mediums. These assumptions are based on the psychoanalytic concepts of regression and psychosexual fixation rather than hard evidence and deserve further investigation.

The last statement hints at a final undertaking: the time has come for art therapy to put aside outmoded psychotherapeutic models and to stand, as it were, on its own two feet. Another look at the two classes of benefits from art making presented in Chapter 5 will serve to reinforce this point.

Art as life enhancement

Art has the capacity to enhance quality of life that can improve the lot of both the sick and the healthy. The evidence for this capacity comes primarily from the thought and research of Dissanayake (1992a, 1992b, 1995), who emphasizes the evolutionary significance of artistic behavior as a means of making important things special, and of Csikszentmihalyi (1990, 1996), who views art activity as one way to engage in optimal psychological experience. Reflection on their conclusions reveals several implications for art therapy.

First, this is an equal opportunities benefit. It can be accessed by anyone with some inclination to engage in art activity and at least minimal

ability to do so – regardless of problem or disability. Second, even though it appears to have nearly universal application, it can be misused. One has to be careful about what is made special, after all. Think of the gang member who makes membership special by adopting certain tattoos or other body decorations or of the individual who glorifies destructive behavior with a compelling pictorial rendition. Third, in order to experience art as life enhancement, a certain investment of effort leading to a product of reasonable quality is required. Without this investment, the result will not give pleasure and the process of creating will not be sufficiently satisfying.

There is another aspect that overlaps with art's rehabilitative properties. Art appears to facilitate development in children (e.g. Sylwester 1998). Thus it is highly important that all children – normal or otherwise – be given ample opportunity to engage in exploration with art materials.

Art as rehabilitation

Art also has characteristics that can be tailored to alleviate specific types of problems. In sum, art is a form of cognition (Solso 1994); it is a component of normal development (Golomb 1992); it is a means of ordering experience (Wilson 1998); it can serve as an alternate method of communication (Alland 1977); it can promote group bonding (Dissanayake 1992a, 1992b) and facilitate creative problem solving (Harth 1993); it can provide success experiences for the severely impaired (B.L. Miller 1998); and it can 'make special' (Dissanayake 1995) the rehabilitative environment. As a consequence of these characteristics, art has the potential to improve or maintain the functioning of those with developmental disabilities, brain damage or deterioration, language impairments, various kinds of mental illness and a variety of problems in living.

In some cases – such as when working with those with degenerative brain diseases – the ameliorative effects may not last much beyond the art therapy session. In other cases – such as when working with those with problems in living – increased self-esteem and new perspectives gained from creating art may lead to more enduring changes. As regards the role of art assessment, the limitations of art-based personality measures (delineated in Chapter 6) should be kept in mind. The evidence is accumulating, however, that the major mental disorders have a more or less predictable

impact on the formal aspects of art. This suggests that investigations of changes that occur in the art products of people stricken with mental illness have the potential to shed additional light on underlying brain processes and, hence, to result in more effective rehabilitative treatments. (A possible area for collaborative research between art therapists and brain scientists is indicated here.)

Some anecdotal evidence

While I was in the process of writing this book, three 'stories' underlined for me the beneficial effects of art making. The first was relayed during a personal encounter. The second was a product of memory. The third I came across in the literature. Relating as they do to the two categories of benefits, they are worth recounting here.

The personal encounter involved a telephone conversation with Dorothy, a former recipient of inpatient art therapy, who told me about her current experiences with art. She had recently enrolled in an art class at a local art center and was excited about the paintings she was producing, finding them expressive and personally satisfying. The approach used by the art teacher was an essentially spontaneous one that involved painting on large pieces of corrugated cardboard, and had been developed as a method of helping blocked artists become unblocked. This approach apparently worked equally well for eliciting creative expression from someone unschooled in art and uncertain of her talent.

Although Dorothy had found her previous participation in art therapy helpful, she credited it primarily to the sensitivity of the art therapist who, she felt, understood her in ways that the other helping professionals had not. The 'art' part of the relationship, which involved a psychotherapy-based approach, had seemed largely incidental. Reflecting on her hospital experience, she remarked that the art therapist, the social worker and the psychiatrist were all doing basically the same thing when it came to therapy. It took an art teacher with a novel approach to show her the gratification that can be gained from concentrated artistic endeavor and to help her create personally meaningful art (Figures 7.1 and 7.2).

The second anecdote concerns a memory from my own art experiences, which surfaced as I reflected on what can be gained from artistic endeavor.

Figure 7.1 Spontaneous figurative painting by Dorothy

Figure 7.2 Spontaneous abstract painting by Dorothy

At the time of this particular experience I was still in the process of mourning the loss of my father who had died two years prior. The resolution of my grief came soon after art making in a class I was taking as part of my doctoral studies. In order to understand what it would be like to be a blind participant in art therapy, we were working with clay in a darkened studio. Our instructions were to use our sense of touch to explore our own faces and then to mold a portrait. When the lights were finally turned on, I gasped in astonishment – the face I had modeled looked like my father! I found this especially surprising since most people who had seen me with both parents remarked that I more closely resembled my mother. The explanation that came to mind was that my fingers had somehow located those aspects of my features that were most like my father's because this was my pressing need.

In any case, the finding of my father in myself had a profound effect on me. My spirits shortly began to rise and my protracted period of mourning was soon over. Whether the art experience was definitive in resolving my grief I cannot say, but at the very least I am certain that it reinforced a healing process. Moreover, I am convinced that my amazement at the outcome of a relatively unrestricted creative process was crucial. I seriously doubt that having been directed to sculpt a portrait of my father would have had a corresponding salutary impact.

A final endorsement for art making comes from Carol Miller's (1998) account of her experiences with the art history-enriched approach that she had previously researched (see above). Working with chronically mentally ill adults, Miller found that her clients were unable to profit from insight-oriented art psychotherapy. Thus she set about devising a method of engaging them in satisfying and rehabilitative art activity. Her approach involves first presenting examples of modern art (works by Jackson Pollock, Paul Klee, Lee Krasner, etc.) and then offering loosely structured art exercises inspired by these examples. In this manner, she overcomes client resistance by making creative activity seem more 'adult' and by assuaging fears of failure. Her approach also provides opportunities for problem solving and decision making within a facilitative framework. Miller reports a number of instances testifying to the efficacy of her work. Particularly noteworthy is the client who told her, 'I regained my ability to concentrate. Before the art, I wasn't able to think or make myself do anything' (p.267).

Such anecdotal evidence is encouraging and in accord with harder evidence. The experiences just recounted illustrate how the doing of art can have beneficial effects outside the psychotherapy context. They constitute good examples of 'art as therapy' – the approach promulgated by art therapy pioneer Edith Kramer. (Interestingly, she was the instructor of the course in which my therapeutic experience occurred.)

Due to their commonalities, these experiences also suggest some of the salient features of an effective art therapy approach. Although investment in the art process is promoted in each case, conforming to a particular standard of excellence is de-emphasized. In addition, a certain loose structure is provided in order to initiate the process and provide some boundaries for the experience. Further, a spontaneous and exploratory engagement with the art media is encouraged. This last point is most likely to be of particular importance for adults who have not participated in art activities since childhood.

Art is certainly not a panacea and may even prove overly stimulating for some people, inducing countertherapeutic emotional states or otherwise exacerbating symptoms. However, for many if not most troubled individuals, the benefits are there for the taking with proper guidance. By and large, the evidence suggests that they can be reaped without recourse to verbal psychotherapy.

Relationship of art therapy to verbal therapy

It appears that art therapy is in a position not only to develop its own theory but also to engage in independent practice. By this I do not mean to imply that art therapy can substitute for psychotherapy, but rather that the gifts which art has to offer do not require a psychotherapy context.

Have we, then, arrived at a final resolution for the 'art as therapy' versus 'art psychotherapy' debate? Possibly. Certainly, art activities can complement psychotherapy by supplementing verbal communication, providing a fresh perspective on a situation, reinforcing therapeutic learning with pictorial illustration, and so on. Conversely, verbal discussions and interventions can enhance some of the therapeutic aspects of art. This is especially the case in regard to the problem-solving abilities of pictorial imagery. But combining art with verbal psychotherapy runs the risk of losing half the advantages art making can bestow; the psychotherapy

session often provides neither the time nor the equipment for executing well-realized art. Perhaps the term 'art therapy' should be reserved for those treatment situations where art in the fullest sense can be produced, regardless of whether or not there is a verbal component. 'Art-facilitated verbal therapy' could be used for much of what has been called 'art psychotherapy'. Along with the change in nomenclature, it should also be acknowledged that the latter type of therapy does not require a therapist with extensive art therapy training.

There are other reasons why art psychotherapy should be de-emphasized as an approach within the field of art therapy. A major justification for including art in verbal psychotherapy has been that, along with dreams, it is 'the royal road to the unconscious'. We now have reason to doubt that art is any more special in this regard than verbal discourse. (Not to mention the fact that our unconscious processes appear to be quite different from what Freud and his followers had envisioned.) In addition, the types of psychotherapy that have received the strongest research support to date are not particularly conducive or amenable to art activity. That is to say, these mainly cognitive-behavioral approaches can usefully employ quick sketches to emphasize therapeutic messages or clarify individual cognitive processes, but there is little inherent in their philosophies and techniques to encourage the kind of art making that truly deserves that term – with the possible exception of some of the stress reduction procedures.

Support for an art-based rather than a psychotherapy-based approach to art therapy also comes from the ethnographic research by Susan Spaniol (1998) – noted previously. Although Spaniol considers her research a pilot study, the results are consonant with the viewpoint of others (e.g. Allen 1992) who put the emphasis on the art in art therapy.

Interviewing a small number of adults struggling with chronic mental illness about their art therapy experiences, Spaniol found that her informants as a whole had a number of preferences. These included: (a) doing art as an activity of living rather than as a form of treatment, thus creating a sense of community in the process; (b) having options rather than being given directives, with the art therapist functioning more as a consultant than counselor; (c) emphasizing product over process, thereby making attractive art pieces available for consolidating identity, personalizing living spaces and gift giving; (d) de-emphasizing spontaneity because

taking care insures quality art and provides a sense of control. Through her study, Spaniol has reinforced a central thesis of the present text. At the very least, she has elicited material that offers excellent hypotheses to be tested by additional research.

Relationship of art therapy to the art world

But an evolving art-based theory of art therapy must differentiate itself in yet another way. As Mildred Lachman-Chapin (Lachman-Chapin *et al.* 1998) points out, arts-and-healing activities have proliferated lately. Artists, rather than art therapists, are conducting many of these activities. Indeed, this new direction in the art world, which involves artists working in health-care environments and in the community, is quite widespread and has attracted attention in both the USA and Britain (Kaye and Blee 1997).

In their article 'Connecting with the Art World: Expanding beyond the Mental Health World', Lachman-Chapin *et al.* (1998) discuss the difficulties art therapists have in participating in the art world (including being accepted as artists) and urge them to enter into the full range of arts endeavors. Articles such as this have revived the controversy about whether the emphasis in art therapy belongs on the art or on the therapy. Cathy Malchiodi, in a recent editorial in *Art Therapy* (1999), succinctly frames the problem: 'If there is an artist's way in art therapy, a specialized knowledge based in art rather than extensively in psychology, and a paradigm which differentiates art therapy from other health care professions, just what [is it]?' (pp.2–3). However, there is a corollary to Malchiodi's question that is just as important: How does art therapy differ from the arts-and-healing movement?

The definitive answers to these questions do not revolve around the issue of psychological savvy – a certain amount of which is desirable for all who strive to help others – and should be sought elsewhere. I agree with Malchiodi that art therapists need to give increased attention to identifying and researching the healing aspects of art. To reiterate a major theme of this book, they also need to pay attention to the significant body of pertinent research already out there. In addition, they need to realize that the scientific method exists and exists for a reason; they do not need to (and should not attempt to) reinvent it. Making research more 'art-like'

will not effectively advance art therapy. Both more art and more science are required. The bringing together of these major ways of knowing has the potential to discriminate the art therapist from the well-intentioned and psychologically aware artist. Likewise, this amalgam should prove instrumental in differentiating art therapy from other mental health disciplines.

In sum

Exploration of the available scientific research has turned up at least partial validation for the two fundamental assumptions of art therapy specified in Chapter 2: (a) art making is inherently therapeutic; (b) art therapists offer something that another professional is unlikely to provide. This suggests that art therapy has two good legs to stand on and that continuing development of the field is well worth the effort.

In addition, the state of our scientific knowledge at this time returns us to art therapy's beginnings – with a new twist. As pioneer art therapist Edith Kramer (1979, 1993) has continued to maintain, art therapy's greatest power resides in using art as therapy. This power, however, does not originate in psychoanalytic concepts nor in the concepts of any other current psychotherapeutic theory. It originates in the nature of art itself.

Afterword

A Call for Dialogue

Some of those interested in art therapy who read this book may think, 'What's all the fuss – I know that *doing* art is the main point.' Others, committed to certain theoretical constructs, may regard it as seriously off the mark. I have to admit that having practiced primarily as an art psychotherapist throughout the clinical portion of my career, and one with a primarily psychoanalytic focus at that, I am a bit astounded by where the scientific evidence has led me. Perhaps this admission makes what I have had to say more credible, perhaps not. Certainly, some or all of my conclusions could be dead wrong. My application of the scientific viewpoint to art therapy has been mainly illustrative and far from exhaustive, and new discoveries are being revealed constantly.

In any case, the picture is not yet complete. More thought, more sifting of the research and more gathering of data will have to be undertaken before anything like the final brush strokes can be added. An interchange of ideas must be an integral part of this process – for every sound theory evolves from the efforts of many individuals. Thus I am issuing a call for dialogue on the topic of an art-based (rather than a psychotherapy-based) theory of art therapy. In doing this, I hope I may be permitted one admonition: those engaging in this dialogue need to be versed in scientific principles and relevant scientific advances. Otherwise, art therapy's canvas will be muddied by pseudoscience and its beauty will not be fully available to provide inspiration and solace to those who need it most.

Appendix

Recommendations for Integrating Science
in Art Therapy Training and Practice

If art therapy is going to make a successful transition into the twenty-first century, art therapists will need to increase their science education and their science mindedness. In addition to knowing art and possessing generic counseling skills, their understanding of science should go beyond (an admittedly important) acquaintance with abnormal and developmental psychology. Ideally, they should also know something about such topics as basic brain anatomy and function, neuropsychology of perception, psychotropic medications and scientific research methods. Although those in leadership positions would require more substantial education in science, changes in training and practice for the majority of art therapists could be relatively modest.

Before reading the following suggestions, note that it is assumed that training in scientific topics and methods would be balanced by at least equal training in art and art making – at both the undergraduate and graduate levels.

Training

In regard to undergraduate preparation, it is recommended that students complete some basic science courses in the natural sciences. It would also be highly advisable for them to take at least fifteen semester hours of behavioral and related science courses, including a course in research methodology. This last point would not only prepare them for doing research in graduate school, but would also help them to evaluate relevant scientific studies published in the research literature of a variety of disciplines. (The most desirable preparation for prospective art therapy students would be to obtain bachelor's degrees in both art and psychology. I realize, however, that the extra year of undergraduate study this would probably entail would be a deterrent to many.)

In regard to graduate study, it is recommended that students take a course in art therapy research and complete an art therapy research project. It would also be desirable for them to take a few courses in relevant scientific subject areas (e.g. medical aspects of treating mental illness, sociobiology, cognitive psychology, etc.). Along with adding new course material, a scientific approach to art therapy graduate training should involve the fostering of a questioning attitude toward all that is taught. Thus, students should be encouraged to seek validating evidence for classroom learning through their experiences with clients in their field placements and with the phenomena of the world in general.

A possible problem, that of adding courses to already loaded graduate curricula, could be surmounted in several ways. Students could be encouraged to take the foundation course in art therapy ('Introduction to Art Therapy') while still in undergraduate school. In addition, extensive study of outmoded psychotherapeutic approaches and questionable projective techniques could be eliminated from graduate curricula. At this stage of our knowledge, these topics would be more properly covered as part of the general history of art therapy rather than as theory and techniques to be thoroughly learned and followed. Implementing these steps would allow directors of graduate programs to prune their offerings, thus making room for more science-oriented courses.

However, taking extraordinary measures to incorporate science courses would not be essential; my own experience as an art therapy educator has indicated that room can be made in most programs for at least one course in research methodology without too much trouble (although removing some of the 'dead wood' from programs has much to recommend it). What would be essential is expanded opportunity for relevant doctoral-level education. Increasing the number of science-minded art therapy educators and theoreticians requires more training in scientific thought and research methods than can usually be obtained at lower educational levels. Until such opportunities are created, some type of supplementary education should be devised to fill the gap.

Some of the forms this education could take have been outlined by Gantt (1998). Along with regular continuing education courses, her suggestions include providing examples of research designs in art therapy literature, developing reading lists, offering resource packets and having discussions concerning pseudoscience, antiscience and science – about the

differences between them and why art therapists seem so susceptible to the former two.

Practice

Science-minded art therapy practitioners employ a variety of styles and approaches. In this, they do not differ substantially from their less science-minded colleagues. They should, however, continually evaluate their methods in accordance with the latest research findings. This does not mean that they should attempt to review papers in all the relevant professional journals – an impossible task. It does mean that they should pay attention to new theory and research presented in the art therapy literature and at professional conferences, and that they would keep up with developments in other areas by reading publications that summarize and interpret these developments. *The Harvard Mental Health Letter*, for example, is a brief monthly newsletter that can assist the helping professional in keeping abreast of the latest information in mental health. Good popular science magazines such as *Scientific American* that review the latest happenings in the world of science can assist in keeping up with other areas of science. Resources like these can then be supplemented by in-depth reading on scientific topics with particular appeal to the individual art therapist.

Along with self-directed reading, it is to be hoped that the scientifically oriented art therapist would take advantage of continuing education opportunities and, further, that a substantial selection of options (such as those mentioned above) would be available from the art therapy community. This approach should provide guidance for practitioners without fatally submerging them in the myriad details of arcane branches of science.

There is one caveat: selection of sources of information must be made with care. In general, authors, publications and continuing education programs with a proven track record of presenting scientifically sound information should be sought out. Unfortunately, as I have attempted to show throughout this book, there is much offered to the unwary in the guise of science that is more fancy than fact.

References

Aldridge, D. (1994) 'Single-case research designs for the creative art therapist.' *The Arts in Psychotherapy 21*, 5, 333–342.

Alland, A. Jr (1977) *The Artistic Animal: An Inquiry into the Biological Roots of Art.* New York: Anchor Books.

Allen, P.B. (1992) 'Artist in residence: An alternative to "clinification" for art therapists.' *Art Therapy: Journal of the American Art Therapy Association 9*, 1, 22–29.

The American Heritage Dictionary of the English Language, 3rd edn. (1992) Boston: Houghton Mifflin.

American Psychiatric Association (APA) (1994) *Diagnostic and Statistical Manual of Mental Disorders*, 4th edn. Washington DC: APA.

Anderson, F.E. (1992) *Art for All the Children: Approaches to Art Therapy for Children with Disabilities*, 2nd edn. Springfield, IL: Charles C Thomas.

Andreasen, N.C. (1996) 'Creativity and mental illness: a conceptual and historical overview.' In J.J. Schildkraut and A. Otero (eds) *Depression and the Spiritual in Modern Art: Homage to Miró.* Chichester: John Wiley and Sons.

Arnheim, R. (1969) *Visual Thinking.* Berkeley and Los Angeles: University of California Press.

Arnheim, R. (1974) *Art and Visual Perception: A Psychology of the Creative Eye: The New Version.* Berkeley and Los Angeles: University of California Press.

Barkow, J.H., Cosmides, L. and Tooby, J. (eds) (1992) *The Adapted Mind: Evolutionary Psychology and the Generation of Culture.* New York and Oxford: Oxford University Press.

Barondes, S.H. (1998) *Mood Genes: Hunting for Origins of Mania and Depression.* New York: W.H. Freeman.

Bender, L. (1938) *A Visual Motor Gestalt Test and Its Clinical Use.* New York: American Orthopsychiatric Association.

Bloomgarden, J. and Netzer, D. (1998) 'Validating art therapists' tacit knowing: The heuristic experience.' *Art Therapy: Journal of the American Art Therapy Association 15*, 1, 51–54.

'Brain imaging and psychiatry – Part I.' (1997a) *The Harvard Mental Health Letter 13*, 7, 1–4.

'Brain imaging and psychiatry – Part II.' (1997b) *The Harvard Mental Health Letter 13*, 8, 1–4.

Calvin, W.H. (1996) *How Brains Think: Evolving Intelligence, Then and Now.* New York: Basic Books.

Chalmers, D.J. (1996) *The Conscious Mind: In Search of a Fundamental Theory.* New York and Oxford: Oxford University Press.

Chapman, L.J. and Chapman, J. (1971) 'Test results are what you think they are.' *Psychology Today 5*, 6, 18–22, 106–107.

Churchland, P.M. (1995) *The Engine of Reason, the Seat of the Soul.* Cambridge, MA: Massachusetts Institute of Technology Press.

Cohen, B.M., Hammer, J.S. and Singer, S. (1988) 'The diagnostic drawing series: A systematic approach to art therapy evaluation and research.' *The Arts in Psychotherapy 15*, 1, 11–21.

Cohen, B.M., Mills, A. and Kijak, A.K. (1994) 'An introduction to the diagnostic drawing series: A standardized tool for diagnostic and clinical use.' *Art Therapy: Journal of the American Art Therapy Association 11*, 2, 105–110.

Corey, G. (1994) *Theory and Practice of Group Counseling,* 4th edn. Pacific Grove, CA: Brooks/Cole.

Cressen, R. (1975) 'Artistic quality of drawings and judges' evaluations of the DAP.' *Journal of Personality Assessment 39*, 132–137.

Csikszentmihalyi, M. (1990) *Flow: The Psychology of Optimal Experience.* New York: Harper Perennial.

Csikszentmihalyi, M. (1996) *Creativity: Flow and the Psychology of Discovery and Invention.* New York: HarperCollins.

Dawkins, R. (1989) *The Selfish Gene,* 2nd edn. New York and Oxford: Oxford University Press.

Dawkins, R. (1998) *Unweaving the Rainbow: Science, Delusion and the Appetite for Wonder.* New York: Houghton Mifflin.

de Waal, F. (1996) *Good Natured: The Origins of Right and Wrong and Other Animals.* Cambridge, MA: Harvard University Press.

Dennett, D.C. (1991) *Consciousness Explained.* Boston: Little, Brown.

Dennett, D.C. (1995) *Darwin's Dangerous Idea: Evolution and the Meanings of Life.* New York: Simon and Schuster.

Diamond, P. (1992) 'The single-case study.' In H. Wadeson (ed.) *A Guide to Conducting Art Therapy Research.* Mundelein IL: American Art Therapy Association.

Dissanayake, E. (1992a) 'Art for life's sake.' *Art Therapy: Journal of the American Art Therapy Association 9*, 4, 169–175.

Dissanayake, E. (1992b) *Homo Aestheticus: Where Art Comes From and Why.* New York: Free Press.

Dissanayake, E. (1995) 'Chimera, spandrel, or adaptation: Conceptualizing art in human evolution.' *Human Nature 6*, 2, 99–117.

Eagle, M.N. (1984) *Recent Developments in Psychoanalysis: A Critical Evaluation.* New York: McGraw-Hill.

Eubanks, P.K. (1997) 'Art is a visual language.' *Visual Arts Research 23*, 1, 31–35.

Farber, B.A. (1996) 'Introduction.' In B.A. Farber, D.C. Brink and P.M. Raskin (eds) *The Psychotherapy of Carl Rogers: Cases and Commentary.* New York and London: Guilford Press.

Feldman, D.H., Csikszentmihalyi, M. and Gardner, H. (1994) *Changing the World: A Framework for the Study of Creativity.* Westport, CT: Praeger.

Fink, S. (1998) 'The search for the origins of human creativity.' *The Oregonian,* 1 July, D11–D12.

Frith, C. and Law, J. (1995) 'Cognitive and physiological processes underlying drawing skills.' *Leonardo 28*, 3, 203–205.

Gantt, L. (1993) 'Correlation of psychiatric diagnosis and formal elements in art work.' In F.J. Bejjani (ed.) *Current Research in Arts Medicine: A Compendium of the MedArt International 1992 World Congress on Arts and Medicine.* Pennington, NJ: A Cappella Books.

Gantt, L. (1998) 'A discussion of art therapy as a science.' *Art Therapy: Journal of the American Art Therapy Association 15*, 1, 3–12.

Gantt, L. and Tabone, C. (1998) *The Formal Elements Art Therapy Scale: The Rating Manual.* Morgantown, WV: Gargoyle Press.

Garai, J.E. (1987) 'A humanistic approach to art therapy.' In J.A. Rubin (ed.) *Approaches to Art Therapy: Theory and Technique.* New York: Brunner/Mazel.

Garber, R. (1996) 'Review of the book *Introduction to Art Therapy: Faith in Product.' American Journal of Art Therapy 34*, 3, 85–86.

Gardner, H. (1982) *Art, Mind, and Brain: A Cognitive Approach to Creativity.* New York: Basic Books.

Gardner, H. (1983) *Frames of Mind: The Theory of Multiple Intelligences.* New York: Basic Books.

Gazzaniga, M.S. (1992) *Nature's Mind: The Biological Roots of Thinking, Emotions, Sexuality, Language, and Intelligence.* New York: Basic Books.

Gilinsky, A. S. (1984) *Mind and Brain: Principles of Neuropsychology.* New York: Praeger.

Glantz, K. and Pearce, J. (1989) *Exiles from Eden: Psychotherapy from an Evolutionary Perspective.* New York and London: Norton.

Goisman, R.M. (1997) 'Cognitive-behavioral therapy today.' *The Harvard Mental Health Letter 13*, 11, 4–7.

Golomb, C. (1992) *The Child's Creation of a Pictorial World.* Berkeley and Los Angeles: University of California Press.

Groth-Marnat, G. (1997) *Handbook of Psychological Assessment*, 3rd edn. New York: John Wiley and Sons.

Grünbaum, A. (1984) *The Foundations of Psychoanalysis: A Philosophical Critique.* Berkeley and Los Angeles: University of California Press.

Harris, D.B. (1963) *Children's Drawings as Measures of Intellectual Maturity: A Revision and Extension of the Goodenough Draw-a-Man Test.* New York: Harcourt, Brace and World.

Harth, E. (1993) *The Creative Loop: How the Brain Makes a Mind.* Reading, MA: Addison-Wesley.

Hayes, A.M. and Goldfried, M.R. (1996) 'Carl Rogers' work with Mark: An empirical analysis and cognitive-behavioral perspective.' In B.A. Farber, D.C. Brink and P.M. Raskin (eds) *The Psychotherapy of Carl Rogers: Cases and Commentary.* New York and London: Guilford Press.

Higgins, R. (1996) *Approaches to Research: A Handbook for Those Writing a Dissertation.* London: Jessica Kingsley Publishers.

Hobson, J.A. (1994) *The Chemistry of Conscious States: How the Brain Changes Its Mind.* Boston: Little, Brown.

Hoffman, D.D. (1998) *Visual Intelligence: How We Create What We See.* New York: Norton.

Holmes, D.S. (1994) 'Is there evidence for repression? Doubtful.' *The Harvard Mental Health Letter 10*, 12, 4–6.

Holt, R.R. (1989) *Freud Reappraised: A Fresh Look at Psychoanalytic Theory.* New York and London: Guilford Press.

Horowitz, M.J. (1994) 'Does repression exist? Yes.' *The Harvard Mental Health Letter 11*, 1, 4–6.

Jamison, K.R. (1993) *Touched with Fire: Manic-Depressive Illness and the Artistic Temperament.* New York: Free Press.

Johnson, D.R. (1998) 'On the therapeutic action of the creative arts therapies: The psychodynamic model.' *The Arts in Psychotherapy 25*, 2, 85–99.

Johnson, G. (1995) *Fire in the Mind: Science, Faith, and the Search for Order.* New York: Vintage Books.

Jolles, I. (1971) *A Catalog for the Qualitative Interpretation of the House-Tree-Person (H-T-P).* Los Angeles: Western Psychological Services.

Junge, M.B. (with Asawa, P.P.) (1994) *A History of Art Therapy in the United States*. Mundelein, IL: American Art Therapy Association.

Junge, M.B. and Linesch, D. (1993) 'Our own voices: New paradigms for art therapy research.' *The Arts in Psychotherapy 20*, 1, 61–67.

Kahill, S. (1984) 'Human figure drawing in adults: An update of the empirical evidence, 1967–1982.' *Canadian Psychology 25*, 4, 269–292.

Kapitan, L. (1998) 'In pursuit of the irresistible: Art therapy research in the hunting tradition.' *Art Therapy: Journal of the American Art Therapy Association 15*, 1, 22–28.

Kaplan, F.F. (1983) 'Drawing together: Therapeutic use of the wish to merge.' *American Journal of Art Therapy 22*, 3, 79–85.

Kaplan, F.F. (1991) 'Drawing assessment and artistic skill.' *The Arts in Psychotherapy 18*, 4, 347–352.

Kaplan, F.F. (1998) 'Anger imagery and age: Further investigations in the art of anger.' *Art Therapy: Journal of the American Art Therapy Association 15*, 2, 116–119.

Kaplan, S. (1992) 'Environmental preference in a knowledge-seeking, using knowledge-organism.' In J.H. Barkow, L. Cosmides and J. Tooby (eds) *The Adapted Mind: Evolutionary Psychology and the Generation of Culture*. New York and Oxford: Oxford University Press.

Karp, S.A. (1990) *Draw-A-Person Questionnaire Manual*. Worthington, OH: IDS Publishing.

Kaye, C. and Blee, T (eds) (1997) *The Arts in Health Care: A Palette of Possibilities*. London: Jessica Kingsley Publishers.

Kimura, D. (1992) 'Sex differences in the brain.' *Scientific American 267*, 3, 119–125.

Kingsbury, S.J. (1995) 'Where does research on the effectiveness of psychotherapy stand today?' *The Harvard Mental Health Letter 12*, 3, 8.

Koglin, O.H. (1999) 'Medical research: Understanding the brain.' *The Oregonian*, 27 January, D11.

Koppitz, E.M. (1984) *Psychological Evaluation of Human Figure Drawings by Middle School Pupils*. Orlando FL: Grune and Stratton.

Kosslyn, S.M. and Koenig, O. (1995) *Wet Mind: The New Cognitive Neuroscience*. New York: Free Press.

Kramer, E. (with Wilson, L.) (1979) *Childhood and Art Therapy: Notes on Theory and Application*. New York: Schocken Books.

Kramer, E. (1993) *Art as Therapy with Children*, 2nd edn. Chicago: Magnolia Street Publishers.

Lachman-Chapin, M., Jones, D.L., Sweig, T.L., Cohen, B.M., Semekoski, S.S. and Fleming, M.M. (1998) 'Connecting with the art world: Expanding beyond the mental health world.' *Art Therapy: Journal of the American Art Therapy Association 15*, 4, 233–244.

Lacks, P. (1984) *Bender Gestalt Screening for Brain Dysfunction.* New York: John Wiley and Sons.

Landgarten, H. (1990) 'Edvard Munch: An art therapist viewpoint.' *Art Therapy: Journal of the American Art Therapy Association 7*, 1, 11–16.

Leedy, P.D. (1997) *Practical Research: Planning and Design,* 6th edn. Upper Saddle River, NJ: Prentice Hall.

Loftus, E.F. (1993) 'The reality of repressed memories.' *American Psychologist 48*, 5, 518–537.

Logothetis, N.K. (1999) 'Vision: A window on consciousness.' *Scientific American 281*, 5, 69–75.

Lusebrink, V.B. (1990) *Imagery and Visual Expression in Therapy.* New York: Plenum Press.

Lynn, D.J. and Vaillant, G.E. (1998) 'Anonymity, neutrality, and confidentiality in the actual methods of Sigmund Freud: A review of 43 cases, 1907–1939.' *American Journal of Psychiatry 155*, 163–171.

Machover, K. (1949) *Personality Projection in the Drawing of the Human Figure: A Method of Personality Investigation.* Springfield, IL: Charles C Thomas.

Malchiodi, C.A. (1995) 'Does a lack of art therapy research hold us back?' [Editorial.] *Art Therapy: Journal of the American Art Therapy Association 12*, 4, 218–219.

Malchiodi, C.A. (1998) 'Embracing our mission.' [Editorial.] *Art Therapy: Journal of the American Art Therapy Association 15*, 2, 82–83.

Malchiodi, C.A. (1999) 'The artist's way: Is it the art therapist's way?' [Editorial.] *Art Therapy: Journal of the American Art Therapy Association 16*, 1, 2–3.

McGinn, C. (1999) 'Freud under analysis.' *The New York Review of Books 46*, 17, 20–24.

McNiff, S. (1998) 'Enlarging the vision of art therapy research.' *Art Therapy: Journal of the American Art Therapy Association 15*, 2, 86–92.

Miller, B.L. (1998) 'A passion for painting.' *Discover 18*, 1, 16–19.

Miller, C.L. (1993) 'The effects of art history-enriched art therapy on anxiety, time on task, and art product quality.' *Art Therapy: Journal of the American Art Therapy Association 10*, 4, 194–200.

Miller, C.L. (1998) 'Ego-strengthening art therapy in a day hospital: Using art history to engage clients.' *Art Therapy: Journal of the American Art Therapy Association 15*, 4, 265–268.

Nathan, P.E. and Gorman, J.M. (eds) (1998) *A Guide to Treatments That Work.* New York and Oxford: Oxford University Press.

Nesse, R. (1997) 'An evolutionary perspective on panic disorder and agoraphobia.' In S. Baron-Cohen (ed.) *The Maladapted Mind: Classic Readings in Evolutionary Psychopathology.* Hove, England: Psychology Press.

Nesse, R. (1998) 'Darwinism and psychiatry.' *The Harvard Mental Health Letter 14*, 7, 5–7.

Orians, G.H. and Heerwagen, J.H. (1992) 'Evolved responses to landscapes.' In J.H. Barkow, L. Cosmides and J. Tooby (eds) *The Adapted Mind: Evolutionary Psychology and the Generation of Culture.* New York and Oxford: Oxford University Press.

Osborn, C.L. (1998) *Over My Head: A Doctor's Own Story of Head Injury from the Inside Looking Out.* Kansas City, MO: Andrews McMeel.

Payne, H. (1993) 'From practitioner to researcher: Research as a learning process.' In H. Payne (ed.) *Handbook of Inquiry in the Arts Therapies: One River, Many Currents.* London: Jessica Kingsley Publishers.

Pfeiffer, J.E. (1982) *The Creative Explosion.* New York: Harper and Row.

Pfeiffer, J.E. (1983) 'Was Europe's fabulous cave art the start of the information age?' *Smithsonian 14*, 1, 36–45.

Phillips, G. (1994) *The Missing Universe and Other Cosmic Riddles.* Ringwood, Australia: Penguin.

Pinker, S. (1997a) 'Against nature.' *Discover 18*, 10, 92–95.

Pinker, S. (1997b) *How the Mind Works.* New York and London: Norton.

Popper, K. (1957/1998) 'Science: Conjectures and refutations.' In E.D. Klemke, R. Hollinger and D.W. Rudge (with A.D. Kline) (eds) *Introductory Readings in the Philosophy of Science*, 3rd edn. Amherst, NY: Prometheus Books.

Ramachandran, V.S. and Blakeslee, S. (1998) *Phantoms in the Brain: Probing the Mysteries of the Human Mind.* New York: William Morrow.

Rankin, A. (1994) 'Tree drawings and trauma: A comparison of past research with current findings from the Diagnostic Drawing Series.' *Art Therapy: Journal of the American Art Therapy Association 11*, 2, 127–130.

Restak, R.M. (1994) *The Modular Brain: How New Discoveries in Neuroscience Are Answering Age-Old Questions about Memory, Free Will, Consciousness, and Personal Identity.* New York: Charles Scribner's Sons.

Richards, R. (1992) 'Mood swings and everyday creativity.' *The Harvard Mental Health Letter 8*, 10, 4–6.

Ricoeur, P. (1970) *Freud and Philosophy: An Essay on Interpretation.* Trans. D. Savage. New Haven and London: Yale University Press.

Riding, A. (1999) 'Yes, artists DO think differently.' *The Oregonian,* 6 May, F7.

Ridley, M. (1996) *The Origins of Virtue: Human Instincts and the Evolution of Cooperation.* New York: Viking Penguin.

Rosal, M.L. (1989) 'Master's papers in art therapy: Narrative or research case studies?' *The Arts in Psychotherapy 16,* 2, 71–75.

Rosal, M.L. (1996) *Approaches to Art Therapy with Children.* Burlingame CA: Abbeygate Press.

Rosal, M.L. (1998) 'Research thoughts: Learning from the literature and from experience.' *Art Therapy: Journal of the American Art Therapy Association 15,* 1, 47–50.

Rosenhan, D.L. and Seligman, M.E.P. (1995) *Abnormal Psychology,* 3rd edn. New York and London: Norton.

Roth, A. and Fonagy, P. (1996) *What Works for Whom? A Critical Review of Psychotherapy Research.* New York and London: Guilford Press.

Roth, E.A. (1987) 'A behavioral approach to art therapy.' In J.A. Rubin (ed.) *Approaches to Art Therapy: Theory and Technique.* New York: Brunner/Mazel.

Rothenberg, A. (1990) *Creativity and Madness: New Findings and Old Stereotypes.* Baltimore, MD: Johns Hopkins University Press.

Rubin, J.A. (1984a) *The Art of Art Therapy.* New York: Brunner/Mazel.

Rubin, J.A. (1984b) *Child Art Therapy: Understanding and Helping Children Grow through Art,* 2nd edn. New York: Van Nostrand Reinhold.

Rubin, J.A. (1999) *Art Therapy: An Introduction.* Philadelphia: Brunner/Mazel.

Sagan, C. (1995) *The Demon-Haunted World: Science as a Candle in the Dark.* New York: Random House.

'Schizophrenia update – Part I.' (1995) *The Harvard Mental Health Letter 13,* 7, 1–4.

Selfe, L. (1977) *Nadia: A Case of Extraordinary Drawing Ability in an Autistic Child.* New York and London: Academic Press.

Sherman, L.J. (1958) 'Sexual differentiation or artistic ability?' *Journal of Clinical Psychology 14,* 170–171.

Shlain, L. (1991) *Art and Physics: Parallel Visions in Space, Time, and Light.* New York: William Morrow.

Shuchter, S.R., Downs, N. and Zisook, S. (1996) *Biologically Informed Psychotherapy for Depression.* New York and London: Guilford Press.

Silver, R.A. (1989) *Developing Cognitive and Creative Skills through Art: Programs for Children with Communication Disorders or Learning Disabilities,* 4th edn. New York: Ablin Press.

Silver, R.A. (1996) *Silver Drawing Test of Cognition and Emotion*, 3rd edn. Sarasota, FL: Ablin Press.

Silverman, L.H., Lachmann, F.M. and Milich, R.H. (1982) *The Search for Oneness*. New York: International Universities Press.

Slavin, R.E. (1992) *Research Methods in Education*, 2nd edn. Boston: Allyn and Bacon.

Smith, D. and Dumont, F. (1995) 'A cautionary study: Unwarranted interpretations of the Draw-A-Person Test.' *Professional Psychology: Research and Practice 26*, 3, 298–303.

Smith, L.W. (1997) *Of Mind and Body: A Scientific American Focus Book*. New York: Henry Holt.

Solso, R.L. (1994) *Cognition and the Visual Arts*. Cambridge, MA: Massachusetts Institute of Technology Press.

Spaniol, S. (1998) 'Towards an ethnographic approach to art therapy: People with psychiatric disability as collaborators.' *Art Therapy: Journal of the American Art Therapy Association 15*, 1, 29–37.

Sulloway, F.J. (1979) *Freud, Biologist of the Mind: Beyond the Psychoanalytic Legend*. New York: Basic Books.

Sulloway, F.J. (1996) *Born to Rebel: Birth Order, Family Dynamics, and Creative Lives*. New York: Pantheon Books.

Sulloway, F.J. (1997) 'Birth order and personality.' *The Harvard Mental Health Letter 14*, 3, 5–7.

Sutherland, S. (1998) *Breakdown: A Personal Crisis and a Medical Dilemma*, 2nd edn. New York and Oxford: Oxford University Press.

Sylwester, R. (1997) 'The neurobiology of self-esteem and aggression.' *Educational Leadership 54*, 5, 75–79.

Sylwester, R. (1998) 'Art for the brain's sake.' *Educational Leadership 56*, 3, 31–35.

Tibbets, T.J. (1995) 'Art therapy at the crossroads: Art *and* science.' *Art Therapy: Journal of the American Art Therapy Association 12*, 4, 257–258.

Tinnin, L.W. (1994) 'Transforming the placebo effect in art therapy.' *American Journal of Art Therapy 32*, 3, 75–78.

Ulman, E. and Levy, B.I. (1975) 'An experimental approach to the judgment of psychopathology from paintings.' In E. Ulman and P. Dachinger (eds) *Art Therapy: In Theory and Practice*. New York: Schocken Books.

Vernon, P.E. (ed.) (1970) *Creativity*. Harmondsworth, England: Penguin.

Vick, R.M. (1998) 'Creative interchange.' *American Art Therapy Association Newsletter 31*, 3, 8–9.

Vyse, S.A. (1997) *Believing in Magic: The Psychology of Superstition.* New York and Oxford: Oxford University Press.

Wadeson, H. (ed.) (1992) *A Guide to Conducting Art Therapy Research.* Mundelein, IL: American Art Therapy Association.

Waldman, T.L., Silber, D.E., Holmstrom, R.W. and Karp, S.A. (1994) 'Personality characteristics of incest survivors on the Draw-A-Person Questionnaire.' *Journal of Personality Assessment 63,* 1, 97–104.

Waller, D. (1991) *Becoming a Profession: The History of Art Therapy in Britain 1940–82.* London and New York: Routledge.

Wanderer, Z.W. (1969/1997) 'Validity of clinical judgments based on human figure drawings.' In E.H. Hammer (ed.) *Advances in Projective Drawing Interpretation.* Springfield, IL: Charles C Thomas.

Whitmyre, J.W. (1953) 'The significance of artistic excellence in the judgment of adjustment inferred from human figure drawings.' *Journal of Consulting Psychology 17,* 6, 421–424.

Williams, K.J., Agell, G., Gantt, L. and Goodman, R.F. (1996) 'Art-based diagnosis: Fact or fantasy?' *American Journal of Art Therapy 35,* 1, 9–31.

Wilson, E.O. (1996) *In Search of Nature.* Washington DC: Island Press.

Wilson, E.O. (1998) *Consilience: The Unity of Knowledge.* New York: Alfred A. Knopf.

Wolf, S. and Bruhn, J.G. (1993) *The Power of Clan: The Influence of Human Relationships on Heart Disease.* New Brunswick, NJ: Transaction Publishers.

Wright, L. (1997) *Twins: And What They Tell Us about Who We Are.* New York: John Wiley and Sons.

Yalom, I.D. (1975) *The Theory and Practice of Group Psychotherapy,* 2nd edn. New York: Basic Books.

Subject Index

Name Index